POSTCARD HISTORY SERIES

# Grand Lake
# and
# Presque Isle

*Judy Kimball*

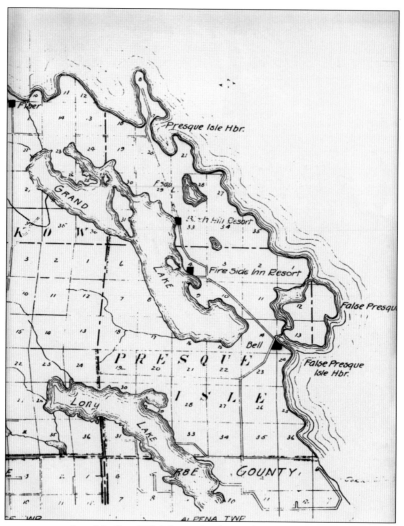

This early map was printed before US 23 was built. It shows the route to Presque Isle going through the community of Bell. It also shows Fisher, which is missing from modern maps because it was a settlement at Thompson's Harbor and has been long since abandoned. (Courtesy of Laurie and Robin Spencer.)

**ON THE FRONT COVER:** This view of Grand Lake includes Cedar and Brown Islands in the distance. The postcard shows a cement and stone break wall, built before regulations governing lakefront construction were enacted. It also shows water draining from Lotus Pond into Grand Lake. This image is unusual in that it looks southward. Most postcards depict the view looking toward the north as one approaches the center of Presque Isle. Perhaps this reflects the joy of arriving rather than the regret when leaving.

**ON THE BACK COVER:** This image of the old lighthouse is most likely from the late 1930s, as it shows the rebuilt cottage. Francis Stebbins, the owner at the time, liked to perpetuate the erroneous fact that the lighthouse was built by Jefferson Davis—as illustrated by the wording on this postcard. In reality, Jeremiah Moors was the builder. Stebbins's son Jim is seen standing in the foreground. (Courtesy of Presque Isle Township.)

POSTCARD HISTORY SERIES

# Grand Lake and Presque Isle

Judith Kimball and John Porter

ARCADIA
PUBLISHING

Published by Arcadia Publishing
Charleston, South Carolina

Printed in the United States of America

Library of Congress Control Number: 2015935743

For all general information contact Arcadia Publishing at:
Telephone 843-853-2070
Fax 843-853-0044
E-mail sales@arcadiapublishing.com
For customer service and orders:
Toll-Free 1-888-313-2665

Visit us on the Internet at www.arcadiapublishing.com

*In recognition of the 100th anniversary of the Grand Lake Association, this book is dedicated to the efforts of all association members—past, present, and future—to preserve the area's wildlife and natural beauty. In a world filled with pressures for commercial development that can too easily result in noise and clutter, true progress is found in preserving what we have.*

(Courtesy of Walter Dawson.)

# Contents

# ACKNOWLEDGMENTS

Publication of this book would not have been possible without research assistance from many individuals and organizations, including Marlo Broad and Robert Lyngos, with the Alpena County George N. Fletcher Public Library; Mark Thompson, with the Presque Isle County Historical Museum; and Malgosia Myc, Leonard Coombs, and other staff with the University of Michigan's Bentley Library and Clements Library.

Other individuals and organizations assisted the authors by providing postcards, images, and information—all of which proved invaluable—including Laurie and Robin Spencer; William Lewis; Robert L. Larsen; Harry Pilarski; Kris Gilmet Davis; Lori VanSchoten; Lolly Rouleau; Kip and Rusty Kauffman; Camp Chickagami alumni; David Miles, with the Charlevoix Historical Society; the family of George R. Swain, including Joyce Swain Benson and Debra Rich; Presque Isle Township; and the Presque Isle Township Museum Society.

Jesse Darland and Jacel Egan, with Arcadia Publishing, provided professional expertise and patient assistance throughout the entire process of creating this book.

Unless otherwise noted, all images appear courtesy of the authors. Additional images appear courtesy of the Alpena County George N. Fletcher Public Library (APL); the Besser Museum for North East Michigan Collection, at the Alpena County George N. Fletcher Public Library (BMNEM); and the Robert Lyngos Collection, at the Alpena County George N. Fletcher Public Library (RL).

The authors will make an effort to make changes and corrections in future editions.

# INTRODUCTION

Happy memories of Grand Lake and Presque Isle are what bring many families back to their summer cottage, rustic resort, or a location they love. These visits provide time for fragmented families to reconnect around a campfire and reestablish the bonds that connect them to each other, and to this special place. For some, the time spent hiking, exploring, fishing, swimming, or just enjoying the beauty and bounty of the woods, water, and land provides an opportunity to rejuvenate the soul. For others, retirement allows some to forego the long ride down state at the end of a visit, as they make Presque Isle home for their golden years.

The French spelling of Presque Isle found on early maps is Presqu'Ile, meaning "almost an island." Many places in the country use the name Presque Isle. The pronunciation "presk aisle" can be heard elsewhere, but in our county and township, the correct pronunciation is "presk eel."

Before our lakes and forests flourished, the area was covered with shallow, warm saltwater seas that were inhabited by lime secreting shellfish and corals. This was during the Devonian period of geologic time, around 325 to 415 million years ago. These creatures left us with limestone to be mined for smelting iron, making cement, providing gravel for roads, and even for processing sugar beets to make sugar. The limestone mine at Port Calcite is less than 10 miles from Grand Lake. Stoneport is within Presque Isle Township, and the township's southern boundary touches the northernmost point of the abandoned Rockport quarry—a popular destination for rock hounds hunting for crinoids, corals, brachiopods, and trilobites.

After the glaciers receded, Native Americans were the first to inhabit this area as transient visitors, hunting and fishing to maintain their nomadic lifestyle. It was almost certainly these Indians who recommended that members of Lewis Cass's 1820 expedition avoid six to eight miles of paddling around the peninsula by portaging across the narrow sandy shortcut. That shortcut today serves as an area of popular public and private beaches. Henry Rowe Schoolcraft, in his epic *Narrative Journal of Travels*, describes the Indians' hunting success while the Cass party camped in the sand of North Bay and Presque Isle Harbor, waiting for the weather to improve.

As shipping increased in the early part of the 1800s, lighthouses were built to aid navigation. In 1838, shortly after Michigan became a state, Congress appropriated $5,000 for a lighthouse to be built at the entrance to Presque Isle Harbor. A request for bids was advertised in Detroit newspapers in July 1839, and Jeremiah Moors's bid of $4,000 was accepted. He acquired materials and contracted for two delivery vessels. Unfortunately, a vicious storm on Lake Huron caused the captains to fear for their lives, and they threw much of Moors's property overboard. As the delay was not his fault, the Lighthouse Establishment allowed Moors to continue the project the following year, but the developer's bad luck continued. After several delays, the lighthouse was

completed and its lamps were lit for the first time on August 27, 1840. Lemuel Crawford, a logger in the area, was named acting lighthouse keeper. He stayed until September 30, 1840, and was paid $3.50 for his month of service. Four other keepers tended the Old Presque Isle Light over the next 20 years. Abraham Lincoln appointed Patrick Garrity to the post in 1861. Patrick and wife, Mary—natives of Ireland—had married in 1859 while living on Mackinac Island, where their son John was born. Additional children, Annie, Mary, Thomas, Kathryn, and Patrick H., were born while the Garrities lived at the 1840 lighthouse. Annie died in December 1868 and is buried in the Presque Isle Township Cemetery. After moving to the 1870 lighthouse, another daughter was born—named Anna in honor of the deceased Annie.

Due to the deteriorating condition of the cottage at Presque Isle's original lighthouse, the government had plans drawn in 1868 to rebuild it. These were never used, as it was decided that a taller light would better serve the shipping industry. In July 1870, Congress appropriated funds for what would become known as the New Presque Isle Lighthouse, and the engineer of the project, O.M. Poe, made famous by designing the locks at Sault Ste. Marie, was able to complete the project before winter arrived. At the same time, range lights were built to guide ships into Presque Isle Harbor.

More staff were needed to operate a fog signal, built just north of the new lighthouse in 1890. It was not until 15 years later that a second dwelling was constructed. Head keeper Tom Garrity and his sister Kathryn moved to the new dwelling in 1905. Other staff members lodged in the lighthouse's original dwelling. Garrity family members served as lighthouse keepers until Thomas retired in 1935.

Frederick George Burnham was born in 1821 in Ohio. In 1840, he arrived at the settlement on Thunder Bay Island and became a fisherman. Five years later, he built docks and a home at Presque Isle Harbor. He employed residents to cut wood to sell to passing steamships. His home served as the local post office, and parts of its foundation are still visible today.

Later harbor developments included Fred Piepkorn's Harbour View Hotel. This hotel offered furnished cottages and a sunbathing beach where the present-day marina is located. In 1956, Louis Stubl purchased four acres at the harbor from Mel Karol, of Alpena, to build Larks Harbor Lodge. Stubl built piers, a store, a restaurant, and a laundromat. He also sponsored boat races in the harbor for several years. That site now consists of a state marina, the Portage Restaurant, and the Portage Store.

Northeastern Michigan's waters are known for their many shipwrecks, and the Presque Isle area is no exception. Albany Bay was named for the ship that was lost there in 1853, and the wreck is still visible just a few feet below the surface of the water. The wreck of the *Portland*, with part of the ship in a lagoon and the remainder off of a nearby point, is a popular skin-diving attraction at the Bell Natural Area. The *Windiate* was the subject of a History Channel documentary and is located several miles off Presque Isle Point. The *Warren* is remembered for the stories of ducks staggering drunk and unable to fly from eating the cargo of fermented grain after visiting the shipwreck off Black Point in North Bay. The *Cuyahoga* is a popular scuba-diving site in the shallow waters of North Bay, and the remains of a wreck assumed to be the *American Union* lie on the stony beach of Thompson's Harbor State Park to this day.

One of Frederick Burnham's lumberjacks was John Kauffman, a native of Tuttlinger, Germany. He was born in 1833 and immigrated to America when he was about 15 years old. He was on his way to Chicago when he was stranded in Presque Isle because the ship he was on ran aground. John cut wood for Burnham for several years. He eventually cleared land at Grand Lake and built a cabin for his home around 1862. He moved the cabin to its current location to avoid snowdrifts at the lakeshore. Today, this homestead serves as the focal point of the Grand Lake Association, which was formed in 1915 as the Grand Lake Improvement Association.

According to a letter by Bliss Stebbins, published in the *Alpena News*, the first "outsiders" at Grand Lake were members of the Grand Lake Fishing and Sporting Club from Adrian, Michigan. After camping near the present location of the Kauffman homestead, they formalized the group's articles of association and bylaws in 1875. The following summer, they built a clubhouse, to which

they added wings in future years. Stebbins noted that the group arrived by ship at Burnham's Landing until 1887, after which they began arriving by stagecoach.

The first summer cottage was built on Grand Lake in 1878 by S.E. Graves. It was constructed next to the clubhouse, where it remains today. Graves acquired the actual clubhouse property and sold it in 1910 to a member of the Presque Isle Lodge's Eddy family. Part of the original building is now incorporated into a private residence.

The early 1900s brought increased tourism to Presque Isle. Birch Hill Hotel was opened for business in June 1901. Eight years later, Fireside Inn registered its first guests. The Grand Lake Hotel opened in 1912 and Presque Isle Lodge in the 1920s. Some visitors began building their own cottages, a few of which remain today.

The beginnings of the community of Bell are somewhat obscure. A Department of Natural Resources sign posted at the Besser Natural Area several years ago states that it was founded in the 1880s, but other research trace its origins to the 1870s. Living history tapes transcribed by one of the authors include recordings of John Charbonneau's granddaughter, Rosalie LaRocque Bussey, claiming that John was one of the first landowners at Bell. He told local Indians that he had purchased the land and they would have to leave. Bell was originally a wooding station and fishing port. It was home to 100 residents, and its structures included dwellings, a boardinghouse, a school, sawmills, a general store, a tavern, a post office, and a brick kiln.

Presque Isle has a rich history as a location for youth camps. Camp Chickagami was established at Lake Esau in 1929 by the Brotherhood of St. Andrew, a worldwide ministry to men and boys in the Episcopal-Anglican Communion. Today, the camp is operated by the Episcopal Diocese of Eastern Michigan.

A lesser-known camp is Kamp Kairphree, which was located at Bell. One of its 1922 advertisements claimed it was the only girls' camp on the eastern side of the state, "Where the winds sing in the pine trees and Lake Huron's wavelets ripple on the sandy shore." It was operated from 1922 to 1927 by the University of Michigan's first official photographer and his wife. The camp was focused on nature study, dancing, arts and crafts, music, swimming, and canoeing.

Whether you have been drawn to Grand Lake and Presque Isle for a youth camping experience, for climbing its two lighthouses, for a vacation, or for a permanent residence, the authors hope that you will enjoy this glimpse at the buildings and scenes that have appeared on local postcards throughout the years.

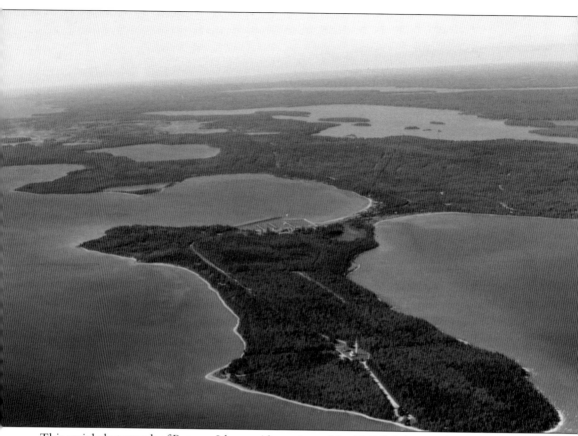

This aerial photograph of Presque Isle provides a view of the 1870 lighthouse, the location of the fog signal, the narrow portage, Presque Isle Harbor, Lake Esau, Grand Lake and some of its 19 islands, and Crystal Point. Airplane and helicopter rides over the area are usually offered each October during the Great Lakes Lighthouse Festival. (Photograph by George Greene, courtesy of Linda Taylor and Lakeshore Realty.)

# One

# ARE WE THERE YET?

One memorable landmark on the way to Presque Isle is this sign south of Alpena on US-23 at Squaw Bay. In David Oliver's early history of Alpena, he explained how he named Squaw Bay. Robert McMullen told of surprising Na-o-tay-ke-zhick-co-quay, a daughter of Chief Mich-e-ke-wis, while she was ice fishing on the bay in 1850 or 1851. She was so startled that she "bounded to her feet with a frightened look" and started toward Partridge Point "with the fleetness of an antelope."

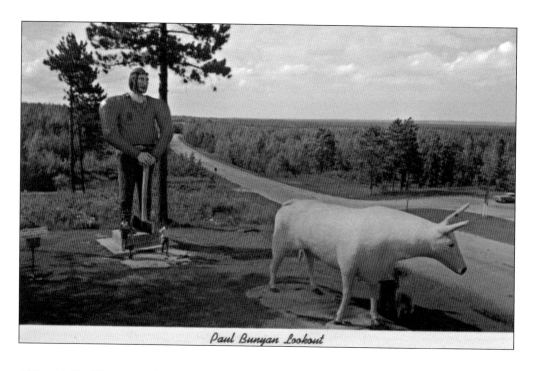

*Paul Bunyan Lookout*

Although Paul Bunyan and Babe the Blue Ox have been moved to Ossineke, they were fixtures in the Harrisville Hills for many years. Vacationers traveling north on US-23 stopped here on the way to Grand Lake to view the statues and to climb the log tower next to them for a view of Lake Huron. Parents told their children tall tales of the giant lumberjack's unusual skills. (Below, courtesy of RL.)

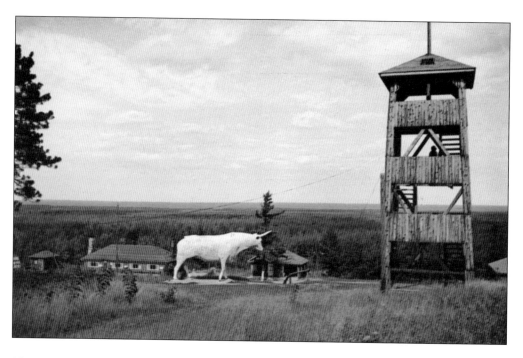

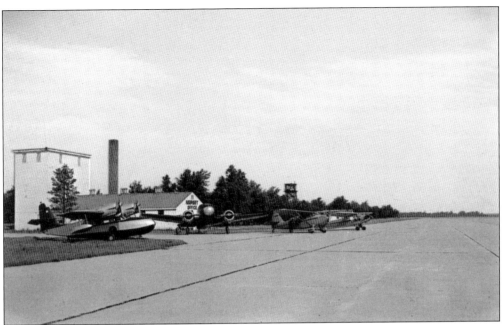

The Phelps Collins Airport was named after a World War I aviation ace with the Lafayette Escadrille. It is the arrival destination for those flying to northeast Michigan. Scheidler Airport was a lesser-known airport, used by small planes, and located just north of Hinks School.

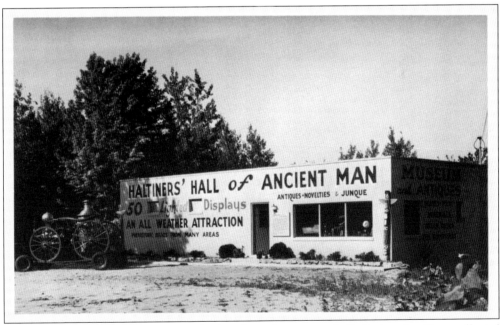

Haltiner's Hall of Ancient Man was a landmark on the way north. It displayed artifacts collected from historical sites throughout northeastern Michigan—many found and identified by Haltiner himself. Today, much of Haltiner's collection is on display at the Besser Museum for Northeast Michigan.

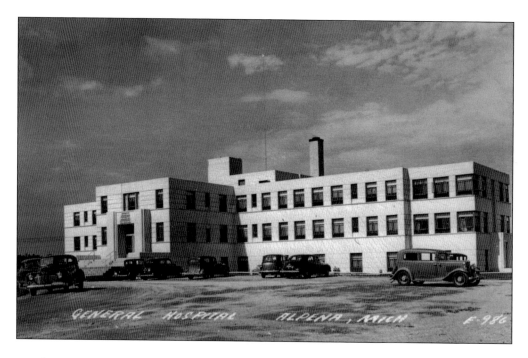

For those traveling to Presque Isle on US-23, getting through Alpena seemed to take forever. Crossing the Chisholm Street Bridge, with Alpena General Hospital in view, meant that the last leg of the journey was at hand. Presque Isle was only one half hour away! In later years, landmarks north of Alpena included the drive-in theater at Bloom Road and the turn at the Hide-A-Way Bar onto East Grand Lake Road. At this point, anxious families knew their northern vacation had begun. (Courtesy of RL.)

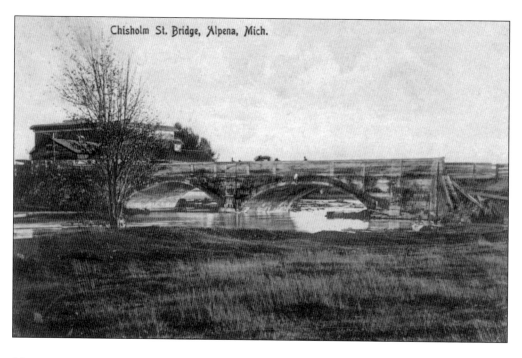

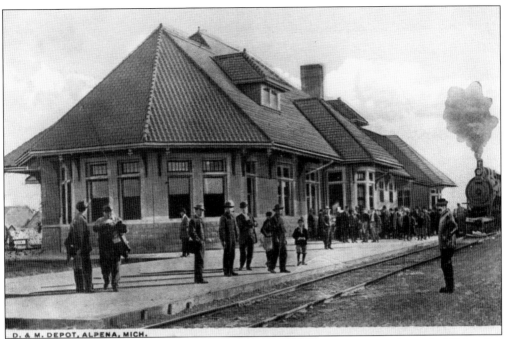

For decades, a popular mode of transportation to Alpena was the train. In the early 1900s, after arriving at the train station, vacationers traveled by horse and buggy to the newly built hotels and resorts at Grand Lake.

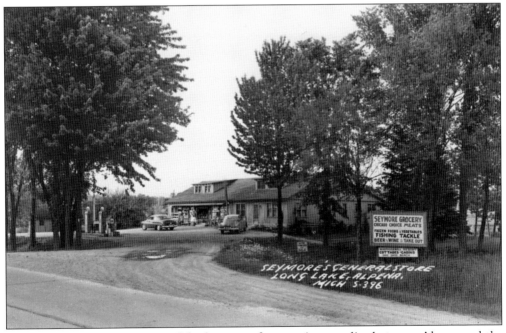

The Seymour Grocery is one of the last stops for camping supplies between Alpena and the Hide-A-Way Bar. Originally, it offered lodging in cabins on nearby Long Lake.

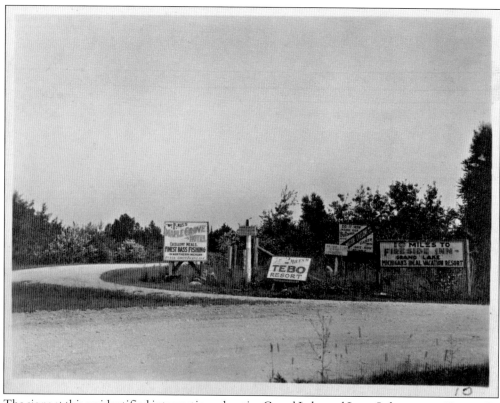

The signs at this unidentified intersection advertise Grand Lake and Long Lake resorts. George R. Swain took several hundred photographs of the Presque Isle area while he and his wife operated a girls' camp at Bell. This photograph, numbered "10," comes from a recently discovered Swain family picture album, which contains about 300 images shot in 1922. It was made available to the authors by the great-granddaughter of the photographer. (Photograph by George R. Swain, courtesy of Joyce Swain Benson.)

This well-maintained gravel road is County Road 638, known to locals as "the road to Rogers City." According to Jerry Smigelski, Presque Isle County road commissioner, the section from East Grand Lake Road to Highland Pines Road was widened and paved from the fall of 1989 to the spring of 1990. Upon returning, summer residents were shocked to see the "new" road. (Photograph by J.R. Young, courtesy of Ilona Stroupe.)

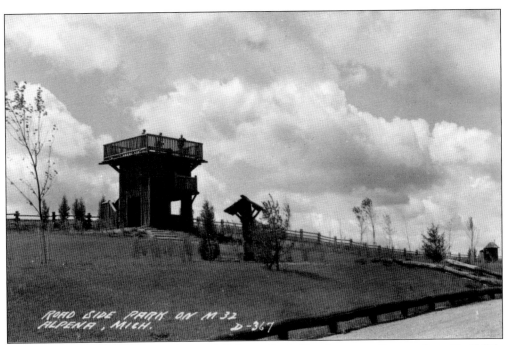

The stockade atop Manning Hill was a delight to climb. For those traveling north on M–65/M–32, it signaled the final stretch of the long journey to Presque Isle. Initially, this structure had a promenade that extended beyond its vertical sides, but eventually the extension was removed in lieu of a simple railing. (Courtesy of Laurie and Robin Spencer.)

Children, including the youthful author-to-be seen in this photograph, would shout to family members below before looking over the farmland and gazing northward toward Presque Isle County. Sadly, the prominence of the current lookout at Manning Hill does not equal that of the structures of days past.

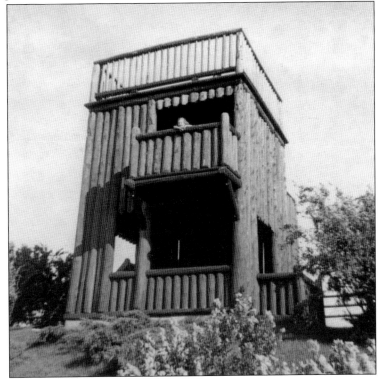

This very early two-track road leading to Presque Isle Lodge inspires visions of Model T Fords or horse-and-buggy travel. Visitors certainly experienced a slow, rough ride to their vacation destination.

ROAD TO PRESQUE ISLE LODGE.    PRESQUE ISLE, MICH.

This early view of Grand Lake Road shows the stretch locally known as "the long swamp road," which extends south of the Rayburn Road intersection for about one and a half miles. This section of the road was eventually raised and paved so its elevation would be significantly higher than the swamp and so snow removed from the roadway would have someplace to accumulate.

Grand Lake Sound, Alpena, Mich.

# Two

# DESTINATIONS

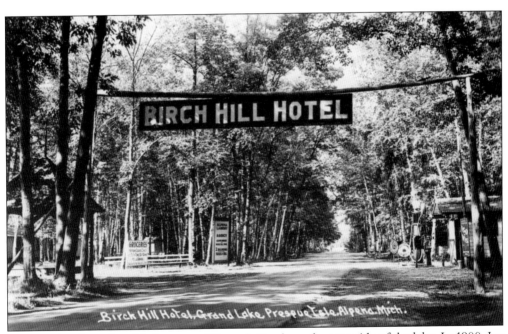

The first hotel on Grand Lake was at Warren's Creek on the west side of the lake. In 1900, Joe Kauffman began to build Birch Hill Resort Hotel on the east side of the lake and opened it in June 1901. It was located across from today's Birch Hill Store. Located on the top of the ridge, its long, covered front porch faced the lake. It offered only primitive accommodations, with outhouses and no running water, but it was in a place of beauty that families enjoyed visiting.

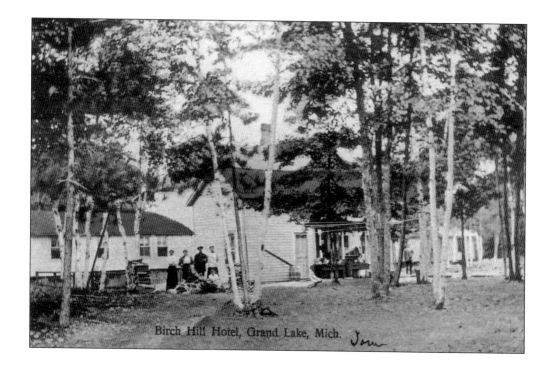

Birch Hill Hotel, Grand Lake, Mich.

Joe Kauffman was very young when his mother died. He was raised by retired farmers in Adrian. After completing college thanks to benefactors, he was able to return to Grand Lake. Restaurant owners from Cleveland camped on his father's land at Grand Lake and encouraged Joe to build a hotel so they would have more sophisticated accommodations. He took their advice seriously, and Birch Hill Hotel was the result.

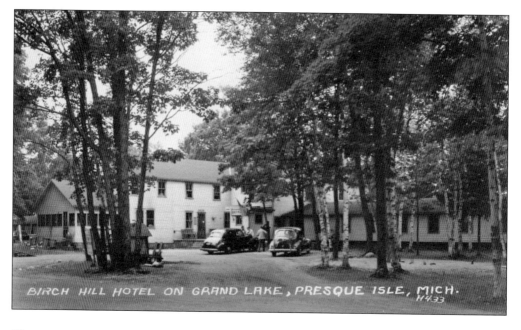

BIRCH HILL HOTEL ON GRAND LAKE, PRESQUE ISLE, MICH.
H-433

Birch Hill Hotel originally offered small, simple rooms, probably no larger than 10 feet by 12 feet. The rooms were furnished with a bed, a bowl and pitcher for washing, a few hooks, and possibly a shelf, but it had no electricity. The construction of the walls featured open studs, which led to the basic and unfinished feel of the rooms. Despite its rustic ambiance, guests sometimes wore attire now considered too formal for a Presque Isle vacation. Dresses and ankle-length skirts for women, and ties and sport coats for men were not unusual in the early part of the 20th century. (Below, courtesy of BMNEM.)

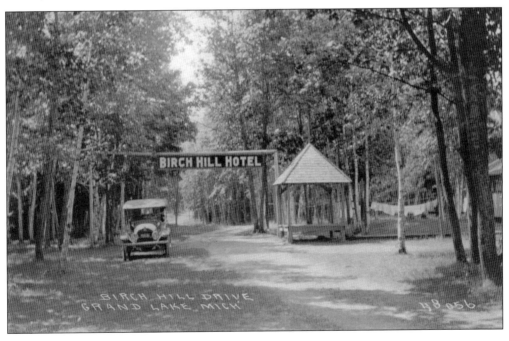

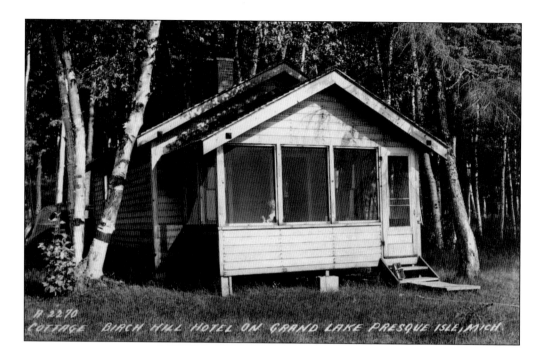

The chore girls employed by the hotel had rooms above the dining room, while the chore boys were housed in the lower level under the recreation room that faced the lake. The girls assisted with housekeeping duties and waitressing tasks, while the boys performed outside maintenance. Cottages were added to give guests more choices for their lodging, and some of them are still used today.

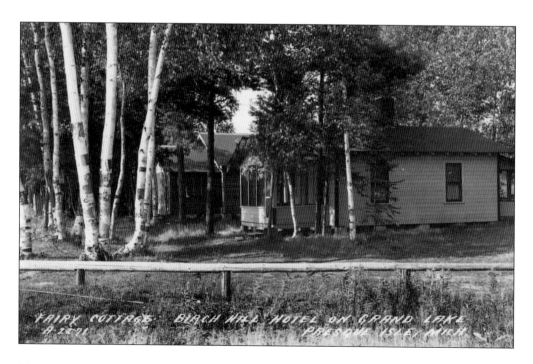

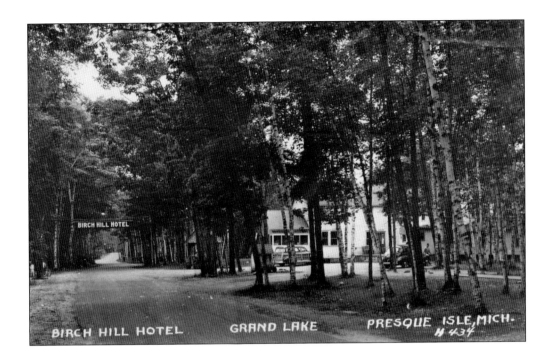

BIRCH HILL HOTEL          GRAND LAKE          PRESQUE ISLE, MICH.
H 434

The winter months provided full-time residents with a period to recover from the hectic activities of the previous season and to plan for the next. Midge Kauffman, daughter-in-law of Joe Kauffman, received letters inquiring about hotel features and requests for reservations during the winter months. These arrangements were handled through the Postal Service. When traveling by bus, plane, or train, people arrived in Alpena and needed to be picked up. The arrangements were confirmed, and times of arrival were shared through letters. (Below, photograph by Campbell Griggs.)

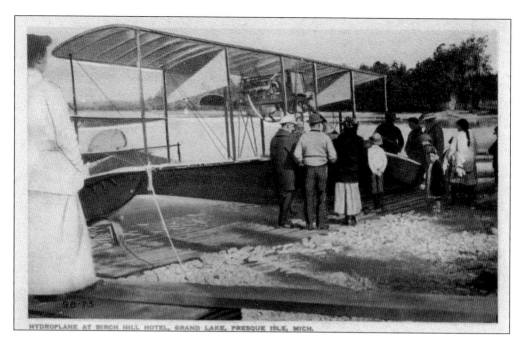

HYDROPLANE AT BIRCH HILL HOTEL, GRAND LAKE, PRESQUE ISLE, MICH.

No one seems to recall these seaplanes landing near the resort. Seaplane services suggest a degree of modern convenience, but there was no dependable telephone service on Presque Isle until well into the 1960s. In fact, the hotel had no telephone service the entire time it was in operation. This is confirmed by Lolly Rouleau, who grew up around the old hotel. Today, she lives on former hotel property with her husband, James. When electricity arrived in Presque Isle in 1940, improvements were made to the hotel; the rooms then featured single lightbulbs hanging from the ceiling. (Above, courtesy of RL.)

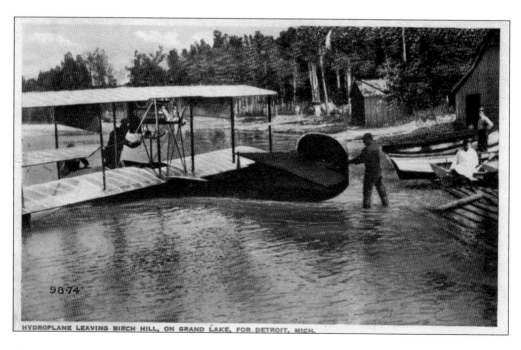

HYDROPLANE LEAVING BIRCH HILL, ON GRAND LAKE, FOR DETROIT, MICH.

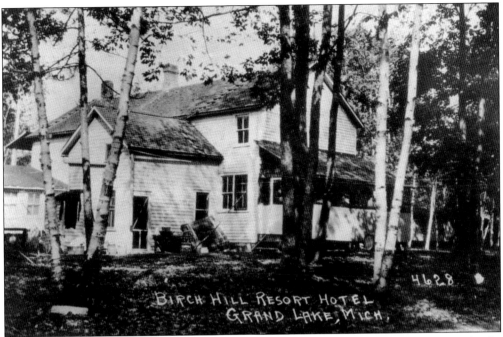

Russell and Midge Kauffman were Joe's son and daughter-in-law. They returned to Grand Lake to help Joe operate the hotel in 1939 or 1940. The Kauffmans converted a couple of the hotel's rooms to communal bathrooms: one for the women and one for the men. Their son Rusty remembers an annual spring chore of sinking all the wooden boats so that the wood would swell and they would not leak for visitors. Rusty also remembers using heavy, thick records from the hotel's Victrola as clay pigeons after the hotel closed in the late 1940s. He and buddy Dan Rivard would shoot at the records as they flew over Grand Lake. Rusty occasionally finds pieces of these records on the bottom of the lake as he puts his dock in each spring.

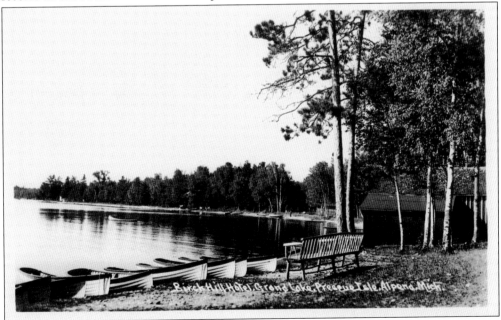

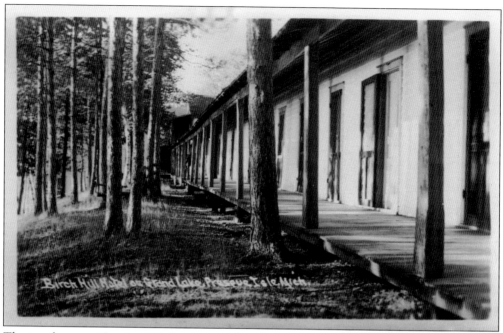

The porch was said to be 400 feet long and at the time was thought to be second in length only to the porch of the Grand Hotel on Mackinac Island. The porch faced Grand Lake, giving visitors a great view of its islands and the dramatic sunsets for which Grand Lake is known. The last year of operation for the hotel was in the late 1940s, but some of the space was later used as a gift shop run by Mrs. Gerald Lawson, a summer resident. Russell and Midge's daughter, Lolly Kauffman Rouleau, remember staying in one of the rooms during the summer after the hotel had closed while she worked at the Birch Hill Dairy Bar. The driveway also served as a parking place for the bookmobile from the district library in Rogers City. (Above, courtesy of Walter Dawson.)

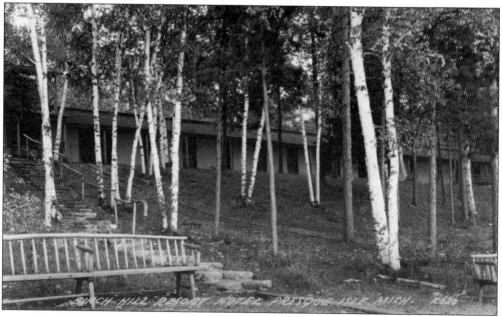

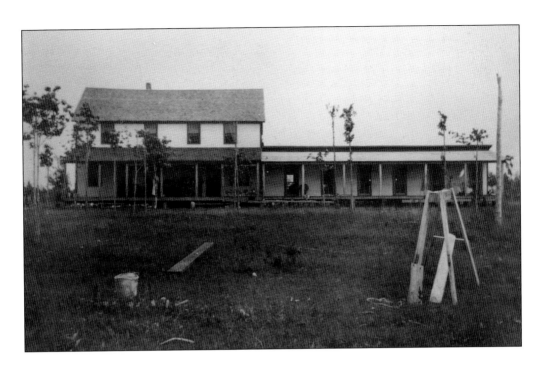

George F. Kauffman built Fireside Inn in 1908. According to his son George H., "Mother saved $350.00 [from lodging wood cutters] and started to talk to dad about building a summer hotel." George F. had reservations because his brother Joe had recently built the Birch Hill Hotel. Visitors enter the inn through a back door in order to approach the registration counter. The front of the inn faces several hundred feet of Grand Lake shoreline. (Above, courtesy of the Clarke Historical Library, Central Michigan University; below, BMNEM.)

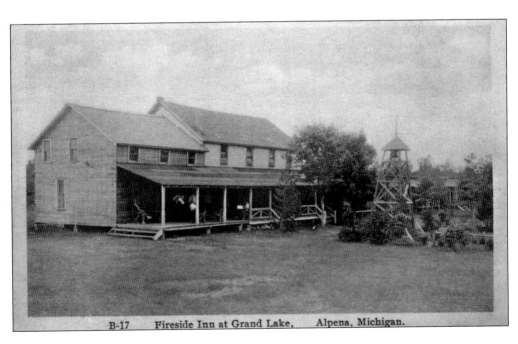

B-17    Fireside Inn at Grand Lake,    Alpena, Michigan.

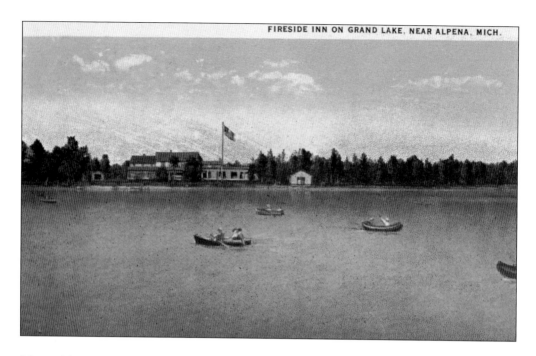

Many visitors came primarily for the fishing, but in the early days there were no motors on the boats. The fishermen would hire a local boy to row or they would have to do it themselves. One of these fishermen, Mr. Hontoon, stayed at Fireside Inn and had a reputation for catching the biggest and the most fish. He did not share his secrets. If anyone approached him while fishing, he would reel in his line and wait for the observer to leave. Present owner Robert McConnell said that in days past if Fireside needed more fish for guests' dinners they would ask Mr. Hontoon to catch some.

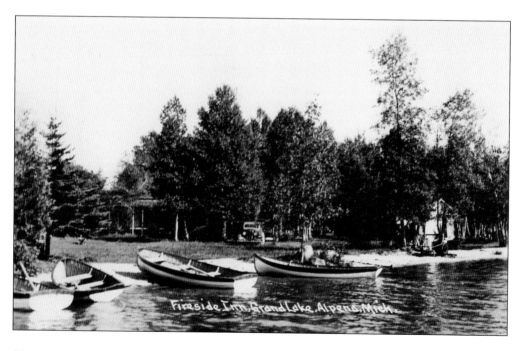

Fireside Inn, Grand Lake, Alpena, Mich.

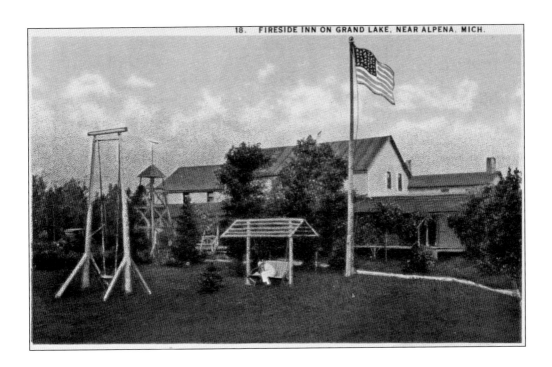

The charms of Fireside Inn included the traditional ringing of the dinner bell, the kids' high swing, and lounge chairs for viewing Grand Lake's dramatic sunsets. Current guests can enjoy disc golf and tennis, plus a variety of waterfront activities that include swimming, boating, and fishing. The rustic atmosphere of the inn's dining room is inviting for guests and locals alike, and everyone is invited to enjoy views of the lake on the veranda before and after meals.

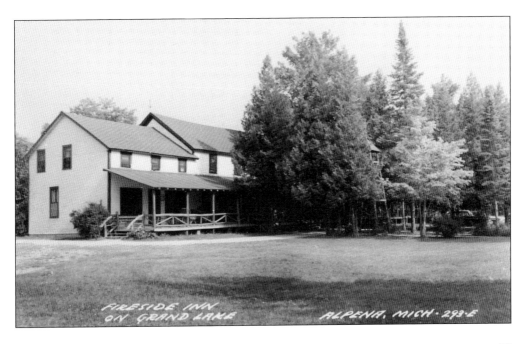

FIRESIDE INN ON GRAND LAKE          ALPENA, MICH. 293-E

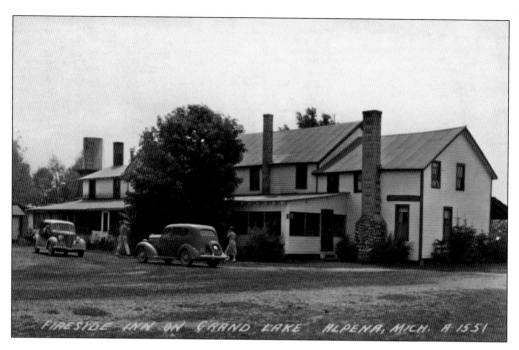

In the days of collecting ice from Grand Lake, the icehouse was an important part of Fireside Inn. In his memoir, Malcolm Powers recalls gathering ice in the winter. Initial cuts were made with an 18-inch circular saw. Since the ice was thicker than that, they had to finish the cut by hand. The 200-pound blocks were moved to the icehouse, stacked, and covered with 18 inches of sawdust. In the summer, Malcolm had to clean off the sawdust and deliver blocks to the iceboxes of the housekeeping cabins and to the icebox on the inn's back porch. The postcard above shows the back porch of Fireside, while the one below shows one of the cottages.

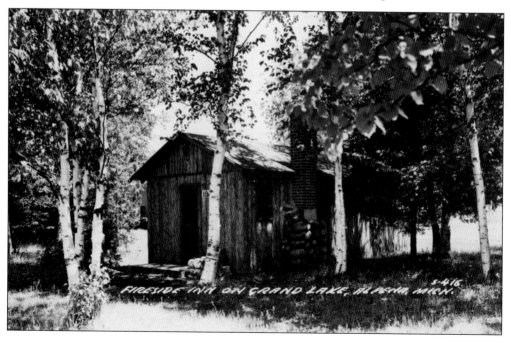

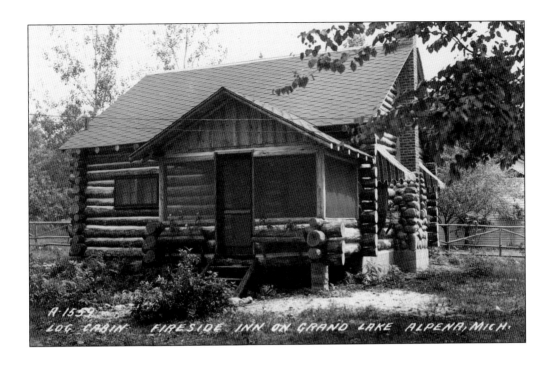

The dance hall craze of the 1920s prompted George H. Kauffman to build a hall at the corner of East Grand Lake Road and Fireside Highway. The craze ended around 1935 and the building stood empty. In 1940, Kauffman tore down the building and used the lumber to start constructing a total of 18 cottages, two of which are seen in these postcards. A one-mile walk on roads near the inn took one past the dump (now a harmless gravel pit), where watching for bears was a popular evening activity.

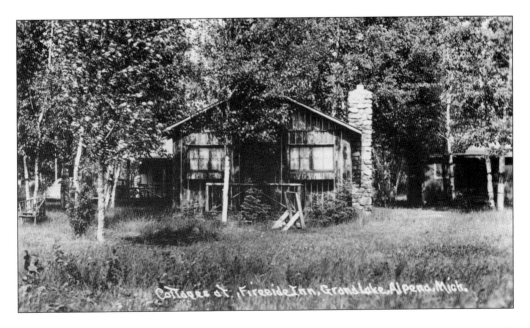

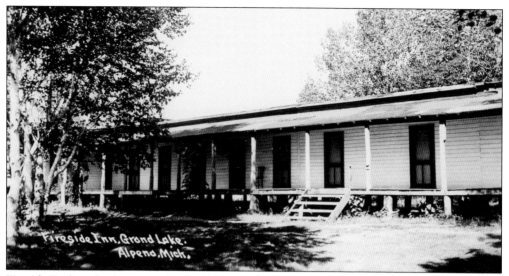

Fireside Inn's gathering room (at the left end of this porch) features a fieldstone fireplace, the second built at Grand Lake. The room also has display cases filled with interesting artifacts found in the area, mounted game, bookcases filled with reading material, a game table, and lounge chairs. One of the authors fondly remembers Joe Schenk showing home movies to guests in this room in the late 1950s and 1960s. Some of these movies showed men in the community building fish shelters. They cut trees, hauled them to the lake's edge, bound them together, added cement blocks, and left them on the ice to fall to the bottom of the lake in the spring.

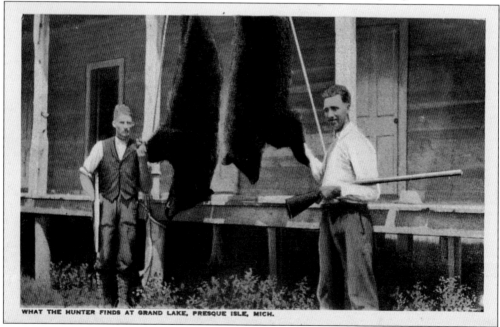

WHAT THE HUNTER FINDS AT GRAND LAKE, PRESQUE ISLE, MICH.

During at least one spring, a fawn was found and kept on the Fireside grounds to be bottle fed by guests; children especially enjoyed feeding Bucky. The practice was discontinued when the tame animal became a nuisance later on in the season. Larger animals were hunted for meat and sport. According to George H. Kauffman, his father, George F., became a well-known bear hunter at 14 years of age and is said to have trapped 42 bears in his lifetime.

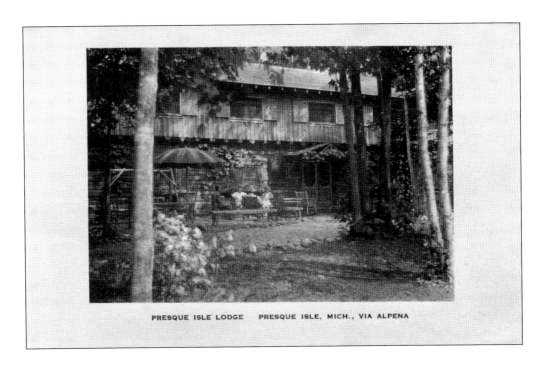

PRESQUE ISLE LODGE    PRESQUE ISLE, MICH., VIA ALPENA

Placed in the National Register of Historic Places in 2008, Presque Isle Lodge was built around 1920 by Newell Avery Eddy Jr. The lodge was built without using electricity. It has been owned and operated as a bed-and-breakfast by members of the Spencer family for over two decades. Many photographs of the lodge appear regularly on its Facebook page, which is maintained by Laurie Spencer. (Above, courtesy of Cynthia and William Doney.)

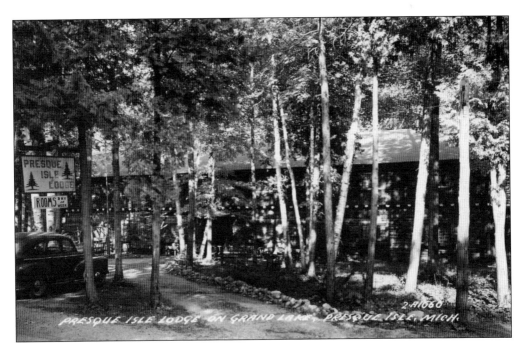

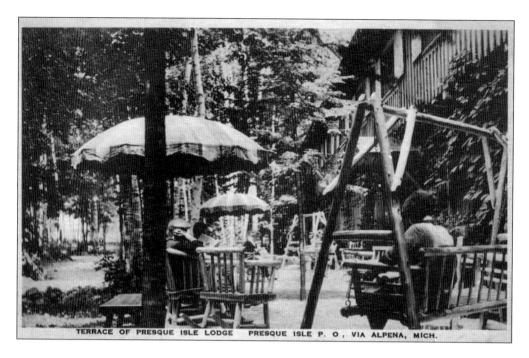

TERRACE OF PRESQUE ISLE LODGE    PRESQUE ISLE P. O., VIA ALPENA, MICH.

Milton and Bessie Underwood bought the lodge from the Eddys. Bessie enjoyed a wide range of lodge duties, including climbing on the roof to replace shingles. Their efforts assured that the lodge would always present a peaceful ambiance in a rustic setting. Guests could sit outside and let their cares and worries vanish. Here, guests are seen relaxing on the lodge's terrace. In the past, an outdoor lounge was located across the road on the ridge above the lake. This provided the perfect place to view sunsets. (Below, courtesy of Laurie and Robin Spencer.)

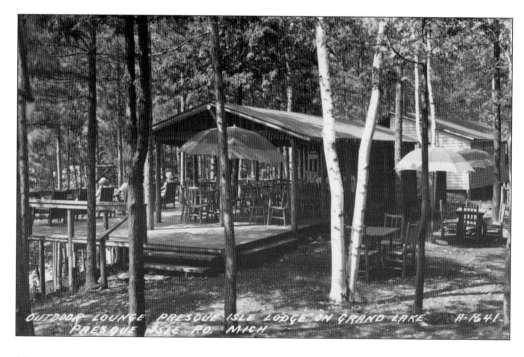

OUTDOOR LOUNGE PRESQUE ISLE LODGE ON GRAND LAKE    A-1641-
PRESQUE ISLE RD. MICH.

These interesting log structures are no longer a part of the lodge. This style of construction was the same as that of the lodge and the Habitat furniture inside. The walkway built around a tree and the lookout allowed guests to feel engaged with the outdoors. These structures added to the atmosphere that the guests enjoyed, which was so different from the one they left in the city.

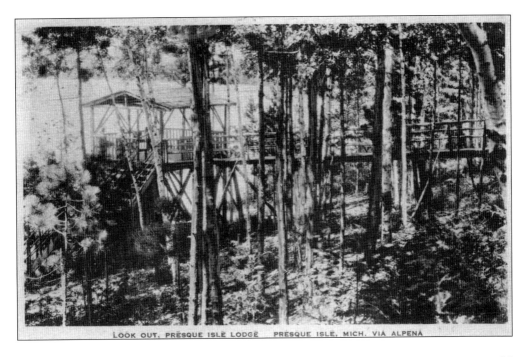

LOOK OUT, PRESQUE ISLE LODGE    PRESQUE ISLE, MICH. VIA ALPENA

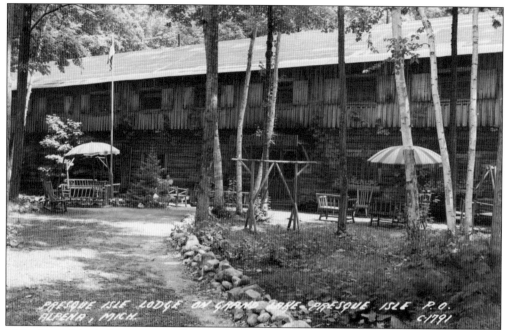

This view of the lodge, with its original driveway, shows the main entrance at the front of the building. Today, most visitors park at the back of the lodge and enter as they would their own home: through a back door.

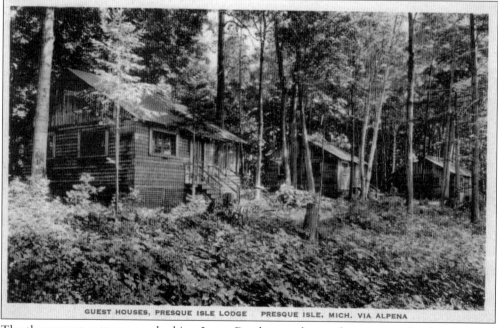

The three guest cottages overlooking Lotus Pond were also used as quarters for the cook and waitresses. Unfortunately, when the lodge stood vacant, the cottages deteriorated and two of them had to be torn down; one has been restored and is in use today. (Courtesy of Laurie and Robin Spencer.)

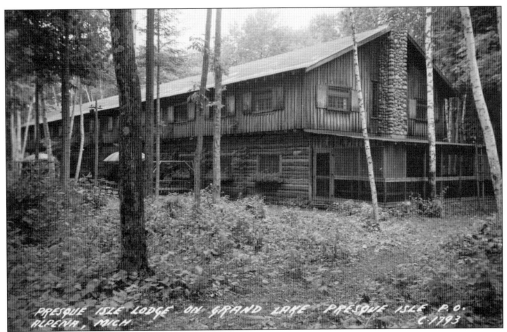

The huge fieldstone fireplace is one of the lodge's main features. The roaring fire is especially inviting during the traditional Memorial Day weekend pancake breakfasts held by the Grand Lake Association. This event provides guests an opportunity to get reacquainted with friends and for everyone in the community to celebrate the beginning of the summer months.

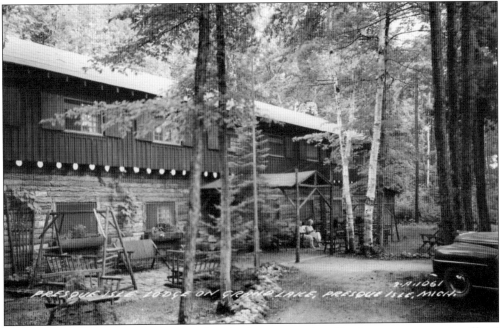

The lodge has long been a gathering place in the community. The Spencers graciously offered the site for events, such as the Grand Lake Association's Game and Pie Night and the annual Pancake Breakfast. It has also been the location for Presque Isle Women's Club activities and the annual Wooden Boat Show party.

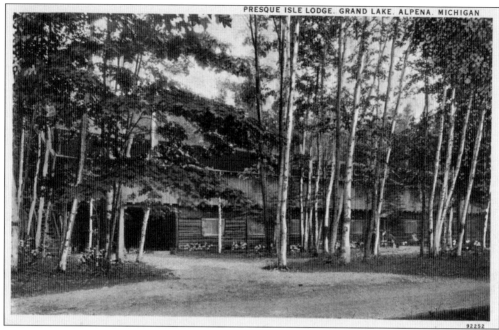

92252

Originally built for fishermen, the rooms at Presque Isle Lodge were small and had Spartan furnishings. There is no air-conditioning, so doorways in the interior hall have both solid wood and louvered doors that allow for cross ventilation from the nice lake breezes. The rooms were remodeled by the Spencers, who combined two or three rooms into one, providing a more comfortable space for today's visitors. The rooms are themed, such as the Black Bear Room, the Fawn and Cub Room, the Pine Cone Room, the Lighthouse Room, the Loon Room, and the Moose Room. The lodge has shared bathrooms. One room has been remodeled into a honeymoon suite with a private bathroom. In the past, outdoor activities were available for guests, including shuffleboard, boating, swimming, and fishing.

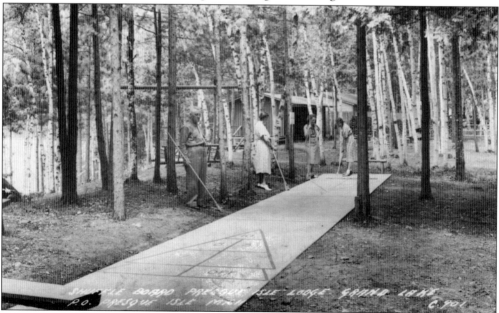

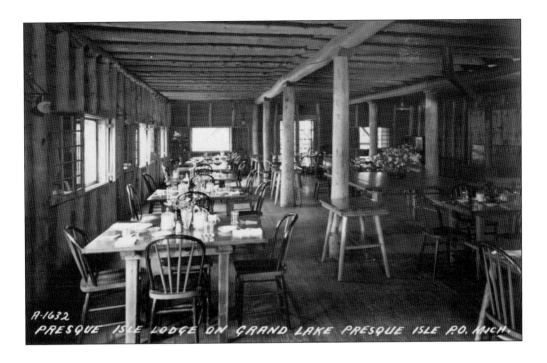

These views of the Presque Isle Lodge's dining room and lounge show examples of its rustic Habitat furniture. The furniture was constructed specifically for the lodge in a workshop behind the building. Due to guests' appreciation of its craftsmanship, the lodge's original owner, Newell Eddy, formed Habitat Shops, Inc. in Bay City to manufacture the rustic furniture for a wider market. (Above, courtesy of Laurie and Robin Spencer.)

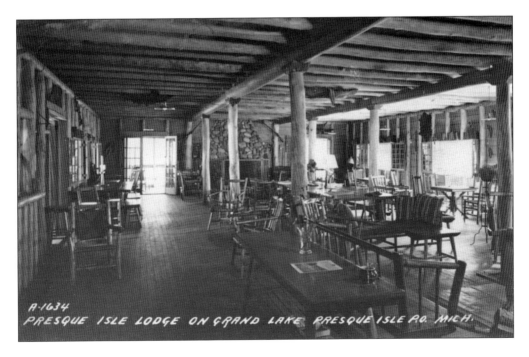

Bliss Stebbins built Grand Lake Hotel in 1912 on East Grand Lake Road. Originally, it had eight bedrooms, four bathrooms, a lounge, a dining room, and a kitchen. Stebbins also built Juniper Lodge for his home, 11 guest cottages, and a boathouse. Today, the original hotel, five cottages, the boathouse, and Juniper Lodge remain. (Above, courtesy of Laurie and Robin Spencer.)

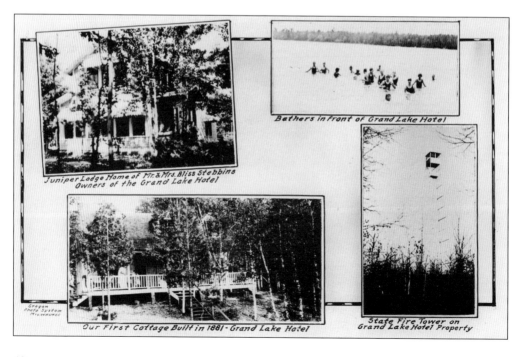

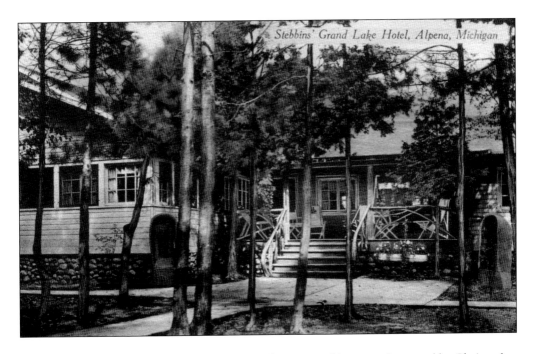

Grand Lake Hotel has had several owners over the years and is currently owned by Christopher Cooper. Current Grand Lake resident Carol Geyer vividly remembers one particular day when she was working as a waitress at the hotel. She was about to enter the dining room, carrying a tray of chicken dinners, when another waitress entered the kitchen through the "out" door. Unfortunately, the dinners carried by Carol ended up on the floor. Because only enough food for the guests and staff had been prepared, there were no chicken dinners for the staff that evening. (Above, courtesy of Robert Currier.)

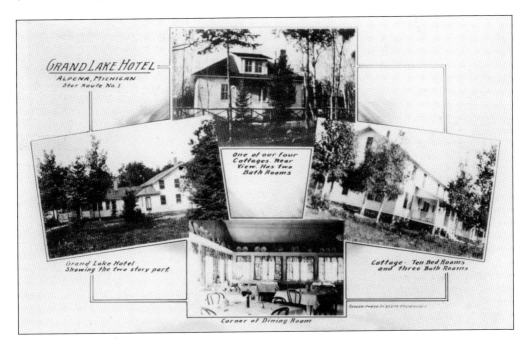

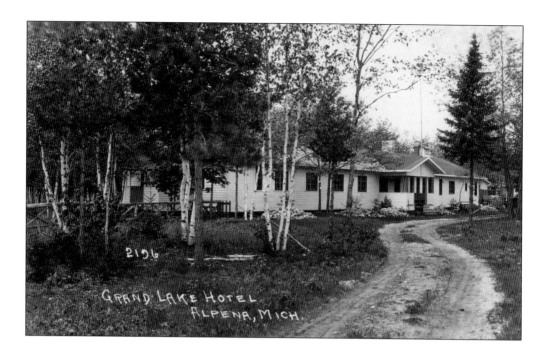

Grand Lake Hotel is located on East Grand Lake Road between Lake Street and Leavitt Drive. These views show the hotel's entrance facing the road. Note the differences in the images that reflect the passage of time. The well-defined two-track entrance has been improved to a gravel drive with a parking area. The addition on the right of the structure appears to be the expanded kitchen area. The trees below are more mature as well, including the small spruce to the left of the entrance. The addition of awnings over the windows protected rooms from morning sunlight and presented a more welcoming appearance.

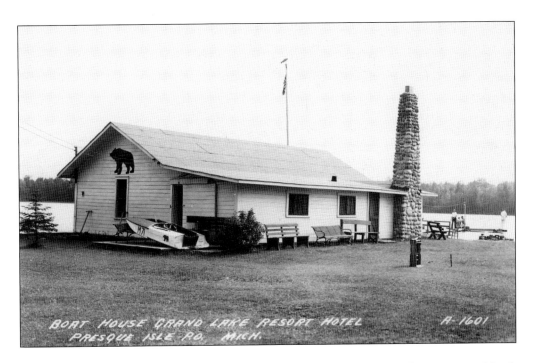

A feature of Grand Lake Hotel was its fabulous frontage on Grand Lake facing Brown Island. From relaxing in lounge chairs or playing a game of croquet, to the excitement and danger of hydroplane racing, the focus of the hotel's activities was at the waterfront. The boathouse sports the hotel's traditional logo: a black bear silhouette. A fieldstone fireplace provided warmth inside, and a deck over the water provided a place for guests, weary waitresses, and housekeepers alike to sunbathe and dangle their feet in the lake.

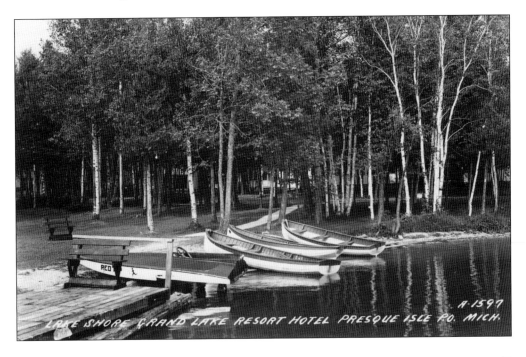

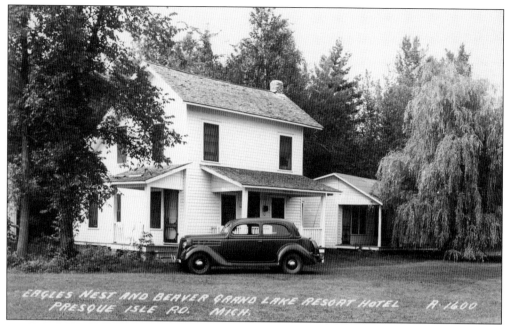

EAGLES NEST AND BEAVER GRAND LAKE RESORT HOTEL    R-1600
PRESQUE ISLE RD.    MICH.

As the hotel's popularity increased, Mr. Stebbins built Juniper Lodge as his personal residence, as well as 11 guest cottages. Future owners subdivided the property. Juniper Lodge and five of the cottages remain.

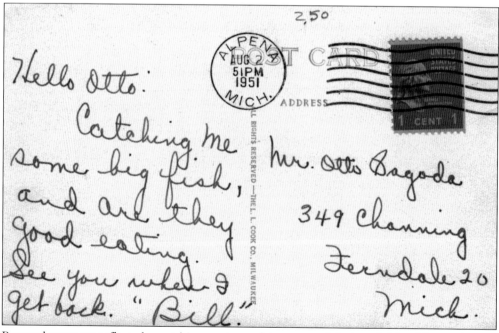

Postcard messages reflected guests' impressions of the area and their activities. They informed friends and relatives of safe arrivals, exciting adventures, and plans for returning home. The happiest of messages often reported on successful fishing trips. (Courtesy of Robert Currier.)

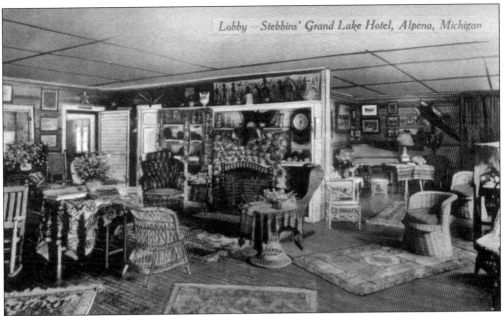

The interior of the main lodge presented a cozy atmosphere. Present owner Christopher Cooper still has the wall clock seen in this image. Young women from Kamp Kairphree were intrigued by the furnishings in the lobby and gift shop during a visit in 1922. The supply of ice cream had not arrived yet, so according to the camp literary journal *KChatter* they "wandered about and feasted their eyes on the gorgeous rugs, dishes, furniture, linens, and pictures. They decided to have some drinks, and went out into the open court where they sat in queer chairs from the Madeira Islands and sipped the liquor luxuriously."

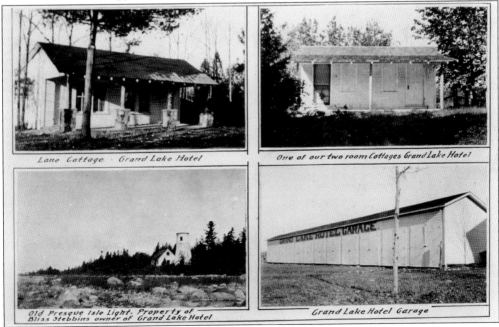

This postcard shows two additional cottages and the old lighthouse as it appeared when Mr. Stebbins owned it. The hotel's garage was located across East Grand Lake Road.

The Opechee Store, now a general store and gas station, was the last commercial establishment Presque Isle visitors passed before turning onto East Grand Lake Road at the Hide-A-Way Bar. Today, there is a collection of enlarged and framed Opechee postcards displayed inside the store near the front door. Some of these cement block cottages remain next to the store on US 23. (Courtesy of Robert Currier.)

These rustic log cabins appear to be at the lakeshore. The authors have been unable to find anyone who knows if they are still standing. (Courtesy of Robert Currier.)

An excerpt from M.R. Potter's unpublished memoir *Years at Grand Lake*, written between 1905 and 1942, states, "We felt we wanted a boat ride and a rest in the woods or on some small lake where we could loaf and fish . . . after the noon meal I secured a horse and buggy and we drove to Long Lake—seven miles to the north—over a fine limestone road. Long Lake looked very inviting with her wooded shores and many small boats."

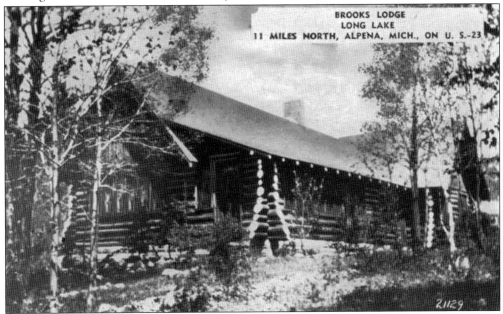

Adonis Heath had Brooks Lodge built in 1935. Today it is called The Friendship Lodge and can be rented for family gatherings. Unlike the large hotels at Grand Lake, it has been available year-round since 1988. It has a great room with a large brick fireplace, and six sleeping areas, including a loft accessible by a stairway. (Courtesy of Robert Currier.)

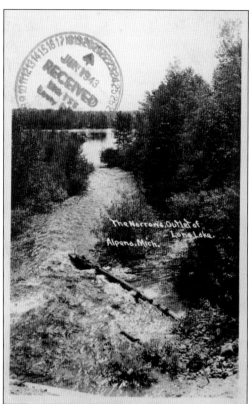

The Narrows is a part of the outlet that allows Long Lake to drain toward Lake Huron. This postcard was sent on June 18, 1943, to a soldier stationed at Lowrey Field in Colorado. The message reads: "Hi Chuck—We are cramming for exams so I'll write you a long letter when school is out. Love, Leonore." The authors found Chuck thriving in Stanwood, Michigan. He is 90 years old. (Courtesy of APL.)

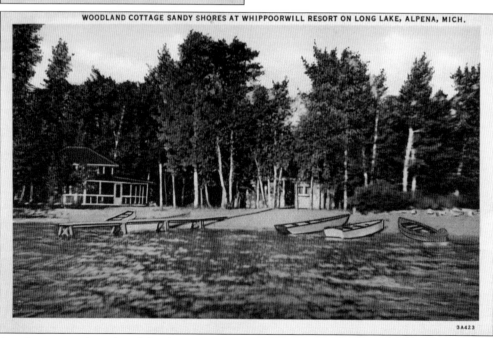

Another postcard produced for the Whippoorwill Resort refers to it as the "Whip-Poor-Will Resort." Whether this name was written with tongue in cheek or was actually the legal name of the resort is anyone's guess now. (Courtesy of RL.)

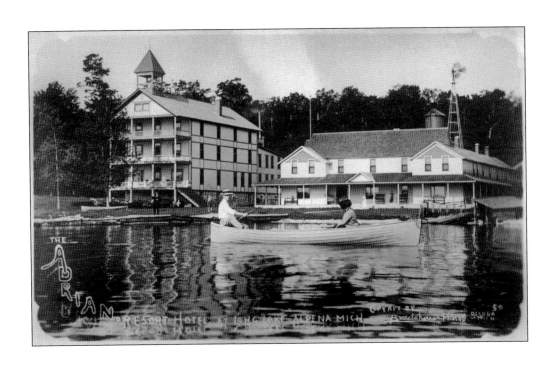

John Beck, an emigrant from Germany, moved to Alpena in 1879. He became one of the first resort owners in northeast Michigan. He owned Maple Grove Hotel and later the Hotel Adrian, both on Long Lake. They were both destroyed by fire. In 1909, he built a new hotel, the Hotel De Beck, which came to be known as Beck's Grand Hotel. It too burned down, about 10 years later. He then took over the rebuilt Maple Grove Hotel. (Both courtesy of BMNEM.)

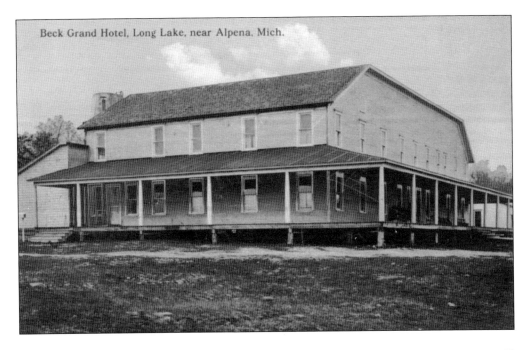

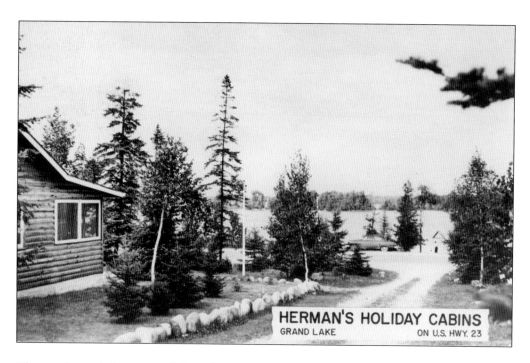

The weather and the current fishing forecast were often common topics for postcard messages. In August 1957, a guest at Herman's Holiday Cabins wrote, "Hi Everyone—Here is where we're staying this wk [*sic*]. The weather has really been cold but it's getting better today. Caught a few fish hope to do better today. Ruth & Kenny." The postcard below shows The Silver Birches on Grand Point in Grand Lake, which has been subdivided into individual parcels since the postcard was mailed in 1963.

This postcard of the Parker House is a compilation of three separate postcards. The restaurant is known for its outstanding breakfasts. The four-acre property includes 13 cabins, efficiencies, and cottages. It was built between 1948 and 1950 by Mr. Parker and is currently owned by Faye and Jac Walker. (Courtesy of BMNEM.)

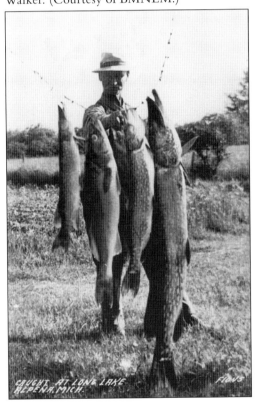

Is there any chance that fish this large are still caught by Parker House guests? (Courtesy of RL.)

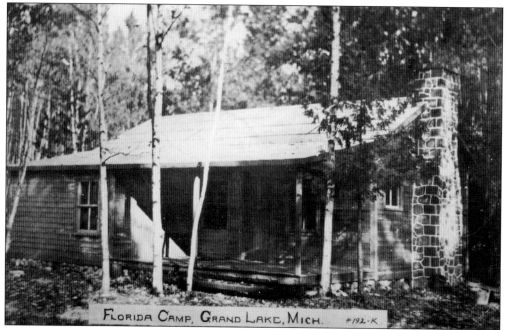

FLORIDA CAMP, GRAND LAKE, MICH. #192-K

The location of Florida Camp is unknown. Was it a solitary cottage or was it associated with one of the large resorts that featured small cottages for guests?

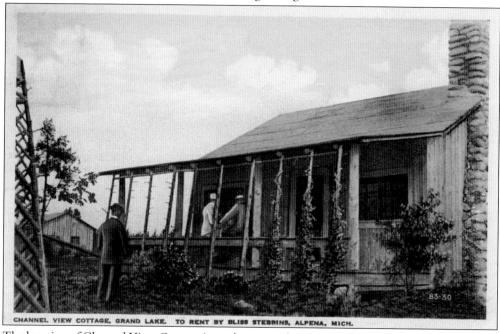

CHANNEL VIEW COTTAGE, GRAND LAKE. TO RENT BY BLISS STEBBINS, ALPENA, MICH.

The location of Channel View Cottage is not known either. It could be the place where six Kamp Kairphree hikers came upon, according to *KChatter*, "Mr. Stebbins and he very kindly procured four suits and caps. . . . A fifth suit was found hanging on the railing, and nobody will tell how the sixth party managed her bath. After a very refreshing swim, the girls carefully removed their wet suits just inside the door and dropped them out on the porch. Since there were no towels the girls discovered that the butterfly dance made a satisfactory substitute." (Courtesy of RL.)

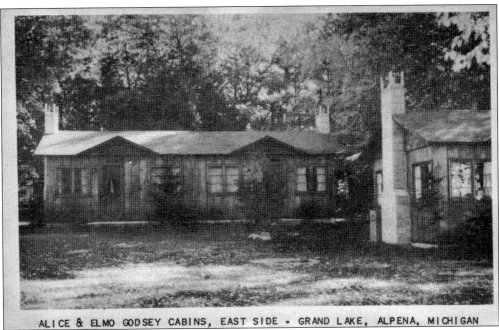

ALICE & ELMO GODSEY CABINS, EAST SIDE • GRAND LAKE, ALPENA, MICHIGAN

Originally, this site hosted a combined home, gift shop, and pharmacy, but it burned down due to a gas leak. The Godseys purchased the property, rebuilt, and added cabins until a total of seven rental spaces were available for guests. Chris and Martha Beach are the current owners. It is located on East Grand Lake Road between Lake Street and Leavitt Drive. They have sold off two of the cottages to the owner of Brown Island. (Courtesy of Chris and Martha Beach.)

Springfield Camp is typical of Grand Lake rental cottages. Youngsters especially enjoyed their vacations at Grand Lake and let their friends at home know it. The message on the back of this postcard reads, "Rose Mary—This is a Deer country alright. Deer here Deer there so long. From Patty."

Camp Chickagami was among 14 boys' camps when it was established by the Brotherhood of St. Andrew in 1929. After serving servicemen in World War I, the Brotherhood turned its attention to developing young men's leadership skills in the hope that future great wars and great depressions could be avoided. Originally, only primitive facilities were available. For many decades, the camp remained a boys' camp during summers, attracting 120 boys for each of four two-week sessions. The camp is now operated for youth of both sexes and is rented to youth-serving organizations for briefer camping programs. A 4-H Natural Resources camp has taken place at Camp Chickagami annually for the last 30 years. Lodging facilities are also rented to families and individuals seeking personal and group retreats. (Both courtesy of Bette and Lee Alden.)

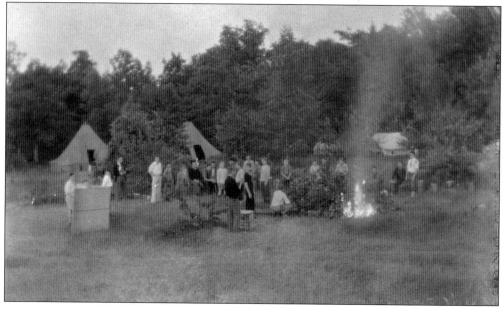

This postcard illustrates the opportunity for personal and spiritual development that has been at the core of the Camp Chickagami experience. A vacation from family and friends, among a milieu of similarly aged youths, fosters a sense of accomplishment and growth. The "thinking rail" provides a place to observe the various moods of the lake and to contemplate one's place in nature and society. (Courtesy of Steve Maunder.)

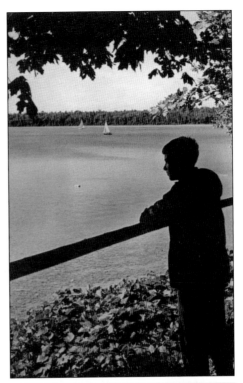

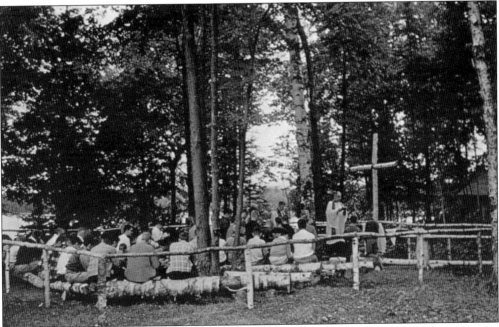

St. Andrew's Chapel at the camp provides an outdoor group worship opportunity that is unforgettable for anyone experiencing it. The camp also has a seven-circuit, classical-style labyrinth with field stone borders. A labyrinth is an ancient, geometric pattern that has a single path that leads into the center and out again. Walking the labyrinth involves the creative and intuitive mind and can be calming and balancing. (Courtesy of Mike Way.)

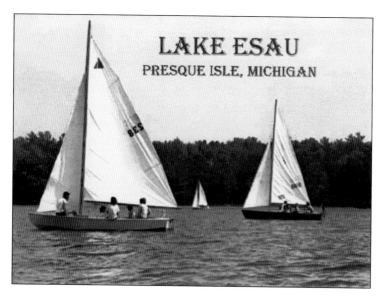

Sports activities are always popular at camp, including sailing. Other sports instruction and competition has included track and field events, tennis, softball, canoeing, and swimming. (Photograph by Lee Alden, courtesy of Katie Taylor and Lakeshore Realty.)

For decades, friendly softball games have served to bond those in the Grand Lake community to those associated with the camp. This photograph shows a camp team practicing in 1961. The games came to an abrupt end in 1965 when a newly installed American Camping Association sign disappeared from the entrance to the camp. The camp's director called for an end to the games until the sign was returned. Unknown to campers and staff and to Grand Lake community members, the sign had been taken by an Alpena resident and proudly displayed in her dormitory room on the campus of Central Michigan University. Three years later, in the fall of 1968, the sign was discovered and returned to the camp's caretaker, Earl Kauffman, allowing for resumption of the annual softball games. (Photograph by Don Sawyer, Sr., courtesy of Tom Grove.)

# *Three*

# COMMUNITY CENTER

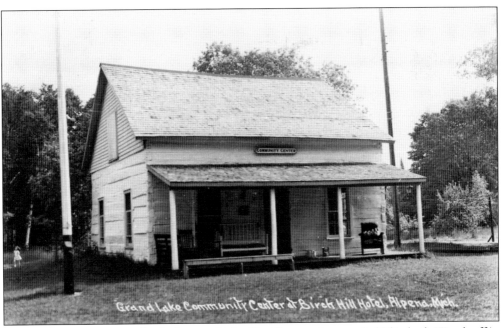

Grand Lake Community Center at Birch Hill Hotel, Alpena, Mich.

This building was originally the home of John Kauffman, who married Elizabeth Woodruff in 1861. They built their log homestead the following year. They had 10 children according to the family genealogy written by Lewis White and Margaret Burke. Sons George F. and Joe remained in the area and played important roles in the history of the Presque Isle community.

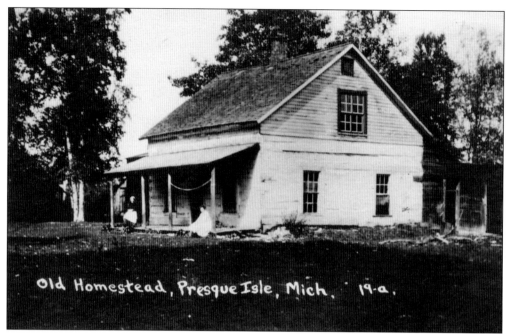

Old Homestead, Presque Isle, Mich. 19-a.

In August 1864, at the age of 31, John Kauffman enlisted in the Union Army in Flint, Michigan. On July 1, 1865, he mustered out of the Army and listed his home as Bell, Michigan. His wife died in 1886, at age 42, leaving him with several young children to raise. He was a fisherman, farmer, and lumberjack. Kauffman was still living in his own home when he died in 1913.

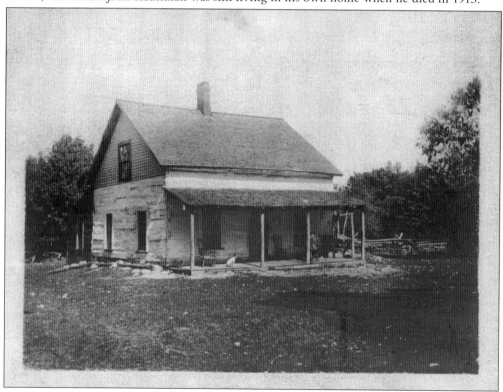

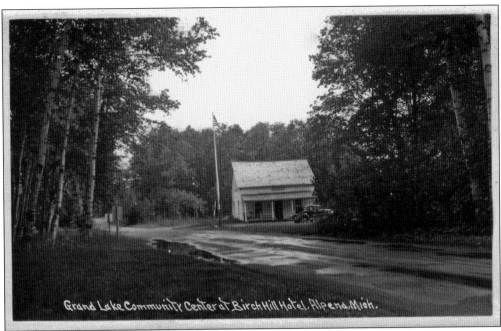

Grand Lake Community Center at Birch Hill Hotel, Alpena, Mich.

The Kauffman homestead eventually became the property of son Joe. Joe let members of the community use the building for gatherings and meetings. When he died in 1949, the property was left to Kauffman heirs, who deeded it to the Grand Lake Association. From then on, it was referred to as the John Kauffman Homestead. It was used for potluck dinners, classes, and other community activities like the outdoor movies that were frequented by friendly bats exiting the house's attic to fly over the heads of the moviegoers. Most recently, it has been used as a gift shop during the summer months. The homestead property includes a tennis court, a volleyball court, and a playground that are available to members of the community. The image below shows the well that was associated with the building. Visible in the background is the Doyle home, which was torn down to build the new Grand Lake Library.

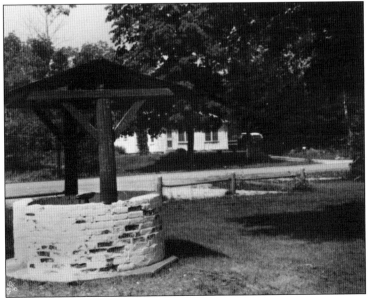

The Colony Club was a local watering hole that offered spirits and a dance floor. It was built by Bliss Stebbins and was a part of the Grand Lake Hotel complex. It was located on the east side of East Grand Lake Road across from the Grand Lake Hotel, where there is now a private home. It was still open when it was destroyed by fire in October 1966. (Courtesy of Presque Isle Township Museum Society.)

Pat O'Conner operated this store by commuting from Detroit on weekends. It was his wish to retire in the Presque Isle community, but he died before he was able to. The store was then owned and operated as a craft shop by Tony Spencer. O'Connor's Store was located south of the current Highland Pines Road and East Grand Lake Road intersection, just south of the Kauffman School. (Photograph by Tony Spencer, courtesy of Laurie and Robin Spencer.)

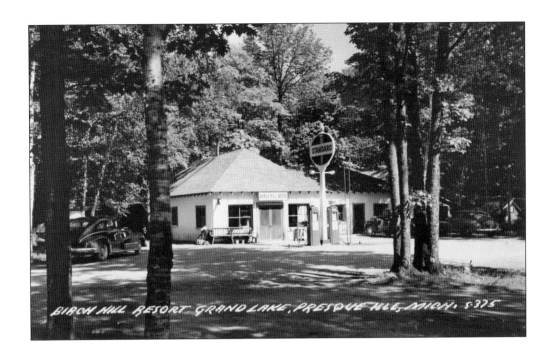

The Birch Hill grocery and gas station has long been the center of business activity in Presque Isle. When Russell and Midge Kauffman owned it in the 1950s and 1960s, it featured a dairy bar popular with teenagers. In earlier years, this was the place to go for ice harvested from Grand Lake. (Below, photograph by Don Sawyer, Sr., courtesy of Thomas Grove.)

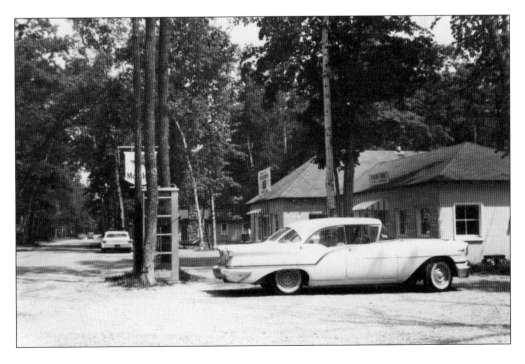

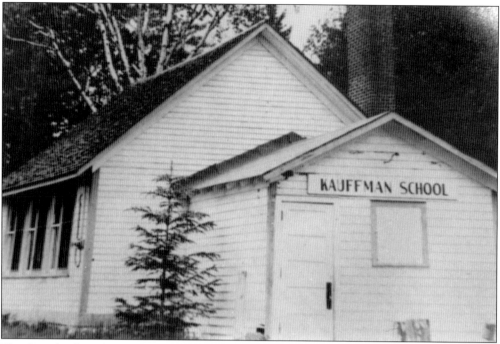

The Grand Lake School, also known as the Kauffman School, was located on East Grand Lake Road, immediately south of the present Lakeshore Realty office on property given to the township by John Kauffman. Longtime resident Mickey Merchant May and her sisters, Carol and Shirley, attended this school along with numerous Kauffmans, Doyals, and Henrys. It served children through the eighth grade and served the community with annual Christmas pageants and the making of maple syrup in the spring. After the school closed, it became home to squatters known to some as the Dead End Kids. After they left, the property was cleaned up, and the building was used as a swap shop. It later became the community's first library.

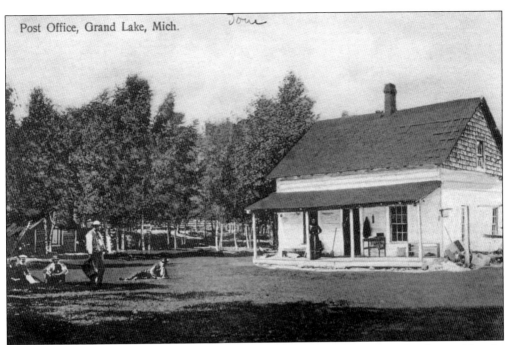

Post Office, Grand Lake, Mich.

John Kauffman was the first Presque Isle Township supervisor and continued in that position for 35 years until his death. He was postmaster and used his home as the post office. After his death, John's son Joe was appointed postmaster, and he moved the post office to Birch Hill Hotel.

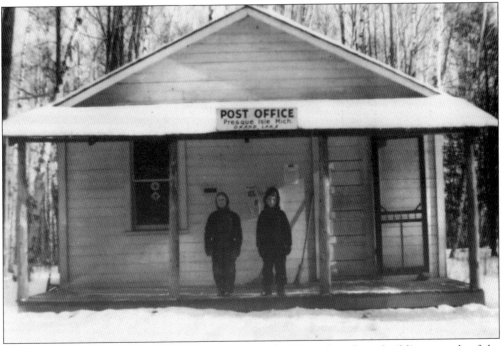

POST OFFICE
Presque Isle Mich.
GRAND LAKE

The post office was eventually moved to its own building, just three buildings north of the current post office. The structure is pictured here, with Rusty Kauffman (left) and Ian Griggs standing in front. (Courtesy of Bill Lewis.)

Lumber was hauled to the site of the township's first town hall in the fall of 1913. It was to be built by J.K. Riblet at a cost of $250. Up until this time, the old Rabiteau boardinghouse in Bell served the community as the site for voting and township meetings. This new building was located at the intersection of East Grand Lake Road and the road serving the Department of Natural Resources launch site, near the south end of Grand Lake. It served the community until the new township hall was built in 1971.

This rustic log structure was located in front of the original township hall. It protected a hand pump for town hall users. A sign, now in possession of one of the authors, was posted on this structure. It reads, "THIS WATER SAFE FOR DRINKING MICH. DEPT. HEALTH 1940–41."

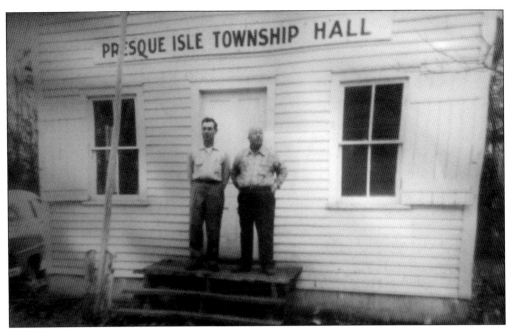

Shown in this image are Russell Kauffman, Sr. (left) and Eli Gilmet. Russell was a community leader who owned the Birch Hill Hotel and was a township supervisor. He was also a school bus driver and is fondly remembered for losing his life saving a young child who had fallen through the thin April ice on Grand Lake in 1964. Gilmet was the community's fire tower lookout for several years. (Courtesy of Presque Isle Township Museum Society.)

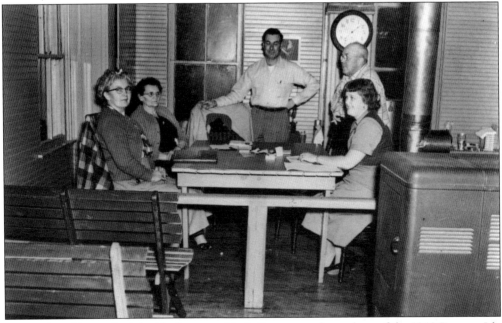

Pictured in this rare look inside the township hall are several members of the 1940 Presque Isle Township Board of Trustees. They are, from left to right, Freda Kauffman (treasurer), Julia Rabiteau (clerk), Russell Kauffman, Sr. (supervisor), Eli Gilmet (trustee), and Helen Zann (trustee, and daughter of Eli). (Courtesy of Presque Isle County Historical Museum.)

Visiting Presque Isle Township Cemetery can elicit sad memories for some. One involves Bobby Kauffman, son of George F. Kauffman. In 1931, boys would carry rifles hoping to shoot some game on the way to or from school so as to have fresh meat for dinner. During one recess, an older student pulled the trigger during target practice. Kauffman accidently put himself in the line of fire to get a better view. He is buried in this cemetery. Obituaries and recorded memories of community members, maintained by one of the authors, can be found in notebooks within the Grand Lake Library.

Three drinking buddies from Presque Isle Harbor made a pact: Charlie Priest, a fisherman, Fred Piepkorn, a tugboat owner and owner of Harbor View Hotel, and Bill Green agreed that when any of them would pass on, survivors would pour a drink down to the departed as a testament to their friendship. Each of these graves is covered with a cement slab that has a hole in it so the libation can easily reach the departed.

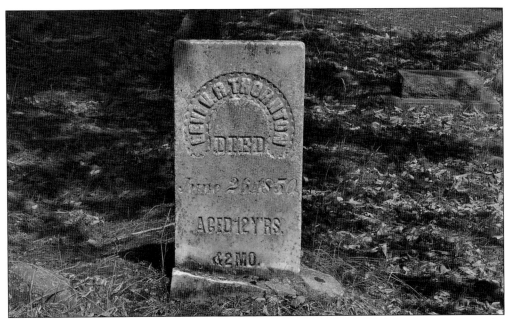

The first burial in Presque Isle Township Cemetery was that of Levi Thornton. He was the 12-year-old son of Stephen Thornton, the third keeper of the old lighthouse. Annie Garrity, the young daughter of Patrick Garrity (last keeper of the old lighthouse and first of the new) is also buried here. She died shortly before her seventh birthday. As far as is known, these are the only lighthouse keepers' family members buried in the cemetery; the cause of both deaths is not known.

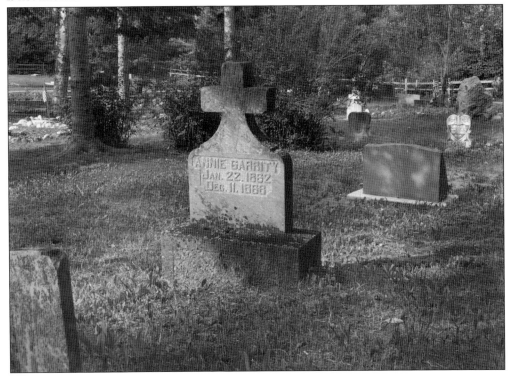

THE LITTLE CHAPEL
ON GRAND LAKE
PRESQUE ISLE, MICH. 2-A-1063

The Grand Lake Chapel was started in July 1945 by Kildow and Barbara Lovejoy, Edith Doyal, Ellen Mumma, and Richard and Iva Poch, a group of property owners. They met at the Kauffman Homestead, by then called the Community Center, to discuss opening a Sunday school. Of two lots chosen, one was donated by Joseph Kauffman, and later two additional lots were donated by the Poirier family. The first service at the Grand Lake Chapel was held on the second Sunday of July 1948. The lawn in front of the chapel is shared with the homestead and has been the site of numerous arts and craft shows over the years. (At left, courtesy of Laurie and Robin Spencer.)

COMMUNITY CENTER PRESQUE ISLE, MICH. S-363

# *Four*

# GRAND LAKE

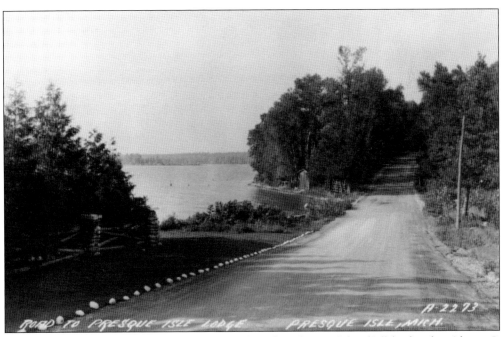

The area shown in this image is affectionately referred to as "the dip" by local residents. It separates Grand Lake and Lotus Pond and has been the subject of postcards for many years. From a two-track road with a log bridge, to a widened gravel road over culverts, to a modern road for today's vehicles, the road across the dip has changed over the years.

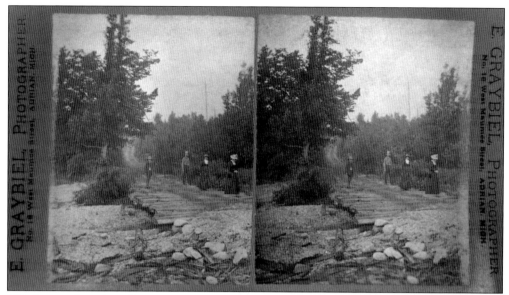

This is one of a series of 26 stereoviews titled *Views of Grand Lake, Presque Isle County, Michigan*. They were produced by Mr. E. Graybiel from Adrian, Michigan, in 1882. The University of Michigan's Clements Library and Central Michigan University's Clarke Historical Library have 10 of these stereoviews. The search for the remaining 16 continues. This stereoview is no. 4 of the set and is labeled, "Lotus Bridge; up the road toward clubhouse." (Courtesy of the Clarke Historical Library, Central Michigan University.)

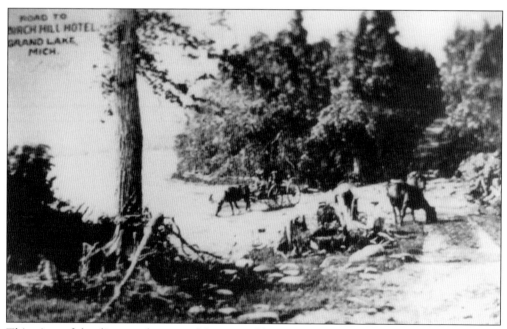

This view of the dip must be one of the very oldest, as animals in photographs of the dip are very unusual. This is also the only known photograph of that location taken during that era to feature a vehicle of any kind. Perhaps this is because people did not want vehicles to ruin the natural beauty of the scene. (Courtesy of Bill and Marian Neale.)

Wagon wheel ruts are clearly seen in this view of the dip. What is not so easily determined is whether the white areas seen in the image are sand or snow. The trees are bare of leaves, but there are no white areas where the road would have been sheltered from the sun. (Courtesy of Judith Wienczewski.)

This is the only known postcard showing Lotus Pond. Placing the stones, one at a time, to raise the road in the distance had to have been done by some of the area's first residents. It must have been a labor of necessity so that the stagecoach and wagons could pass through this wet, low area more easily. (Courtesy of Walter Dawson.)

ROAD TO THE RIDGE, GRAND LAKE, PRESQUE ISLE, MICH.

These two images of the same area may have been captured within a short time of one another. The "Grand Lake View" postcard below was mailed on September 16, 1923. The message reads: "It is so darn cold I cannot even smell the pines! However it seems a wee bit warmer than it was & I have great hopes.—Hattie."

GRAND LAKE VIEW

This older view of the dip shows the utility poles that provided telephone service to the new lighthouse. The image is dated 1912, and electricity did not arrive in Presque Isle until 1940. (Courtesy of the Clarke Historical Library, Central Michigan University.)

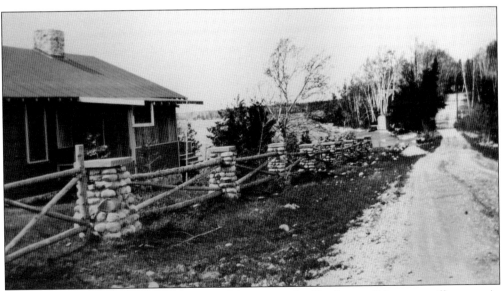

This home has been remodeled and can still be seen at the dip. Some of the stone pillars remain and can be seen next to the road. This is the first clear view of Grand Lake that travelers get on East Grand Lake Road as they approach the center of the community and the last that they get as they head south. (Courtesy of the Clarke Historical Library, Central Michigan University.)

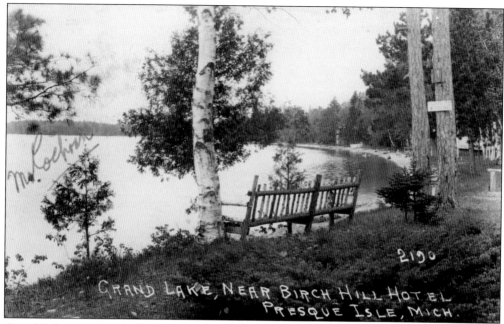

Grand Lake is rather shallow by the standards of Michigan's other large lakes. According to *Michigan Inland Lakes and Their Watersheds: An Atlas*, it is the state's 15th largest lake, based on surface area, and the eighth largest in terms of shoreline distance. (Courtesy of the Clarke Historical Library, Central Michigan University.)

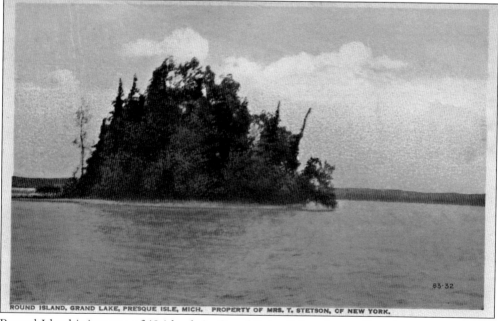

Round Island is just one of 19 islands in Grand Lake. It is quite small, and a cottage actually covers most of the island. Were the Kamp Kairphree girls referring to Round Island when they recorded in their literary journal *KChatter*, "We had heard terrible tales of there being bear, rattlesnakes, lynx, deer and porcupine on the island and everyone was properly scared before starting out but we all decided to be brave."

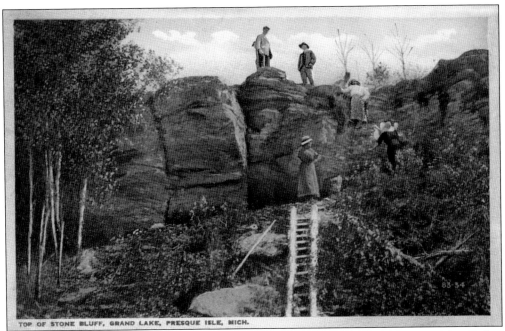

The stone bluff on the west side of Grand Lake provides a panoramic view of the lake. Today, US 23 is located above this ridge, 50 feet above the lake. The explorers in this image would be amazed at the proliferation of cottages and homes along Blue Horizon Road at the base of this bluff. (Courtesy of Laurie and Robin Spencer.)

Farm animals are rarely seen in postcards of Grand Lake and Presque Isle. This image shows the contour of the land, apparently at the south end of Grand Lake. The exact location of this field is unknown. (Courtesy of RL.)

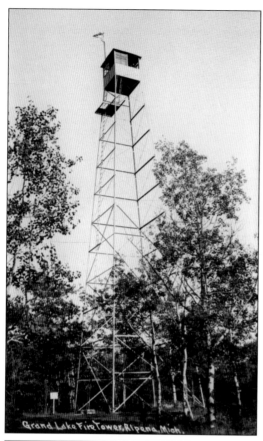

Grand Lake Fire Tower, Alpena, Mich.

The first fire tower in Michigan was built at Higgins Lake in 1913. Beginning in 1927, resident Eli Gilmet served as tower man for several years, working at the tower shown at left. He worked 10-hour days from April 1 to October 15 and could not leave his post without a supervisor's approval. Even when he did leave his post briefly, he had to lower the flag, signifying that someone was not present, or risk dismissal. This tower was located behind the current fire station on East Grand Lake Road. Visitors were always welcome to make the climb to the top of the tower. Gilmet found humor in some of their questions, such as one from a Detroit visitor who, after her arduous climb, asked how he managed to get water to the top of the tower to put out the fires.

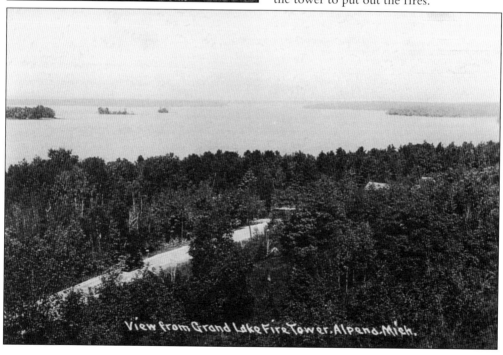

View from Grand Lake Fire Tower, Alpena, Mich.

Crescent Island is one of the closest islands to the Community Center and is located about 500 feet off of Grand Lake Boulevard. Before the dam was installed at the outlet, it was possible to walk out to the island during some summers. Spaulding Cottage is visible in the image above of the entire island, and the photograph of the cottage below is dated 1914. At one point, this was the only island in Grand Lake that had electric power provided by a power company. The power line stretched from the mainland to the island. Eventually, the line was submerged in the lake. (Below, courtesy of the Clarke Historical Library, Central Michigan University.)

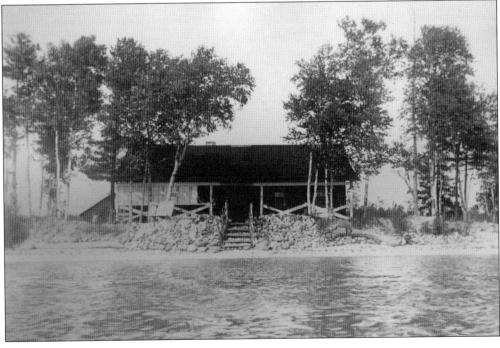

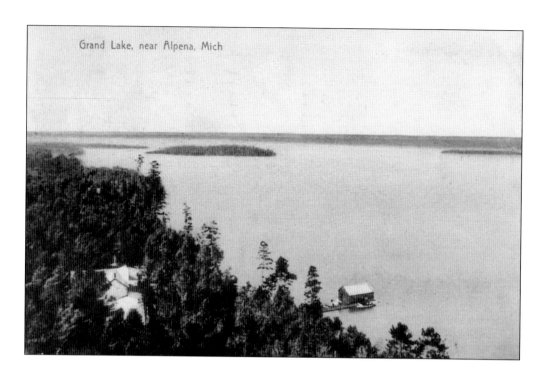

Grand Lake, near Alpena, Mich

The Grand Lake Clubhouse is visible in the bottom left corner of the postcard above. A better view is provided in the stereoview below, dated July 29, 1882. This group from Adrian, Michigan, was called the Grand Lake Party Group. Its report of a typical day, written four years earlier, states, "Today we have been all over Grand Lake. The point is covered with splendid red raspberries. Like true sons of the forest the men went after the pigeons while their wives picked the berries, and a fine bag of them (I mean the pigeons) . . . assures us of meat for tomorrow." (Below, courtesy of the Clarke Historical Library, Central Michigan University.)

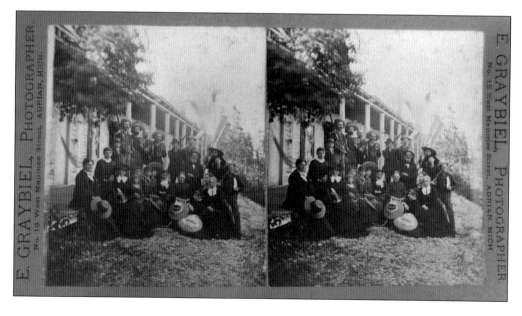

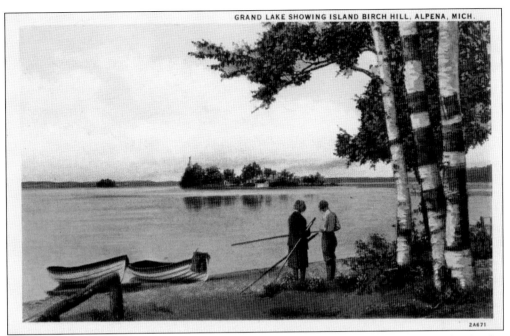

2A671

This postcard shows both the Spaulding Cottage and its boathouse on Crescent Island. This same image appeared in the March 1928 issue of *The National Geographic* in an article entitled "Michigan, Mistress of the Lakes," along with 66 other images.

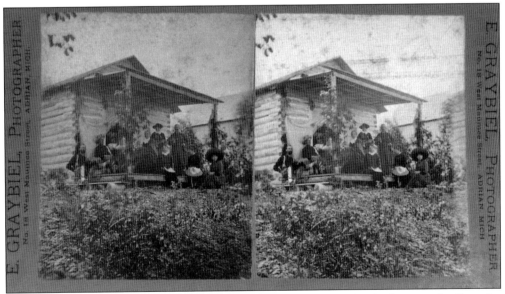

Graves' Cottage was the first cottage built at Grand Lake. It remains in the same family today and is located between the post office and the dip. It now has a small kitchen, a bathroom, and an enclosed porch, but from the outside S.E. Graves would certainly recognize the cabin he built in 1878. (Courtesy of the Clarke Historical Library, Central Michigan University.)

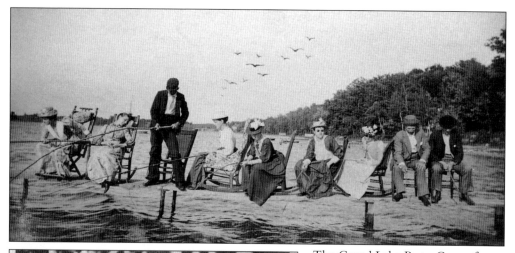

BLACK BASS, PRESQUE ISLE LODGE
PRESQUE ISLE P. O. VIA ALPENA, MICH.

The Grand Lake Party Group from Adrian is seen above gathered on the dock in 1887 and using sticks and twigs for fishing poles. No doubt the two serious-looking gentlemen in the postcard at left used more sophisticated fishing tackle. Ten years earlier, Francis Stebbins wrote to the Adrian paper that "a drizzling rain set in this morning but this afternoon the sky is clear, the air cool, and the lake and islands are in their most beautiful phases. Mrs. Worden was 'high line' today in size of fish, having caught a fine, large pickerel." (Above, courtesy of Bentley Historical Library, University of Michigan; at left, Laurie and Robin Spencer.)

One Days fishing at Grand Laka Mich

In 1907, fishing at Grand Lake was very different from that done today. In those days, there were no fishing licenses and no daily limits. Outboard motors were not yet widely available, but even with less sophisticated fishing tackle there were plenty of fish to be caught. (Both courtesy of Laurie and Robin Spencer.)

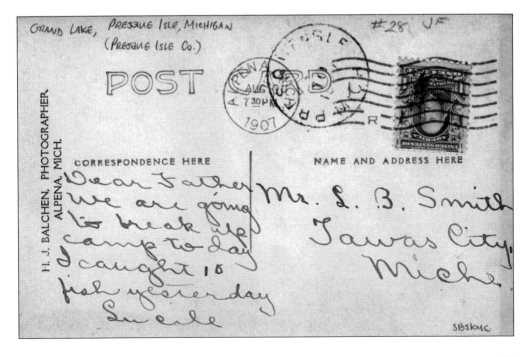

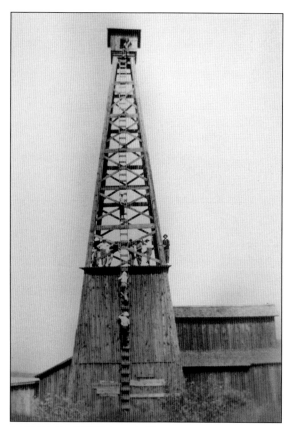

These buildings, located on the west side of Grand Lake, were across from Fireside Inn. They are no longer standing and little is known about the operation. What is known is its name, the Preston Salt Well, and that the photographs were taken in 1914. The derrick was a landmark for those fishing at the best spot on Grand Lake. (Both courtesy of the Clarke Historical Library, Central Michigan University.)

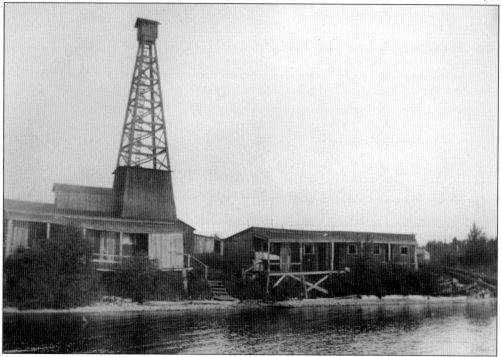

Creating a shoreline highway from Detroit to Alpena was discussed in the 1920s and 1930s. Eventually, construction was begun. One of the objectives of building US 23 was to encourage tourists to travel north via the eastern side of the state. The road to Alpena was completed in 1937. The route through the Harrisville Hills was chosen rather than the planned shoreline route. This would present travelers with a change of pace from the flat terrain of the southern sections of the route. Unfortunately, many thought the hills were too challenging. In recent years, some of the hills have been leveled out somewhat and the road widened. It was not until 1940 that the section of road from Alpena to Rogers City was completed. (Above, courtesy of BMNEM.)

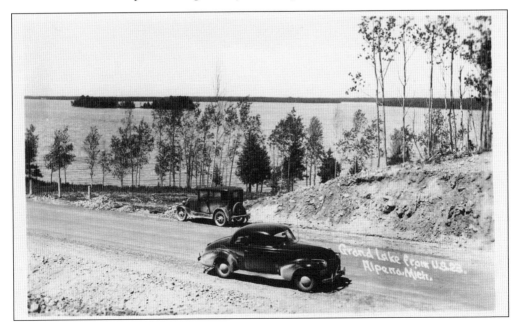

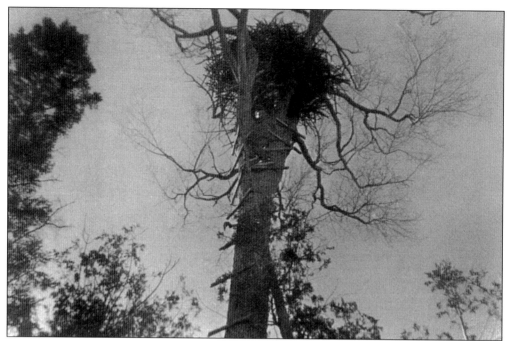

This nest at Black Bass Bay was once ideally situated for the resident eagle's hunting. The middle section of the narrow strip of water between Macomber Island and the mainland was filled in to provide access for vehicles, and the swampy area on the mainland was filled in for residential development. The nest and the tree are no longer present.

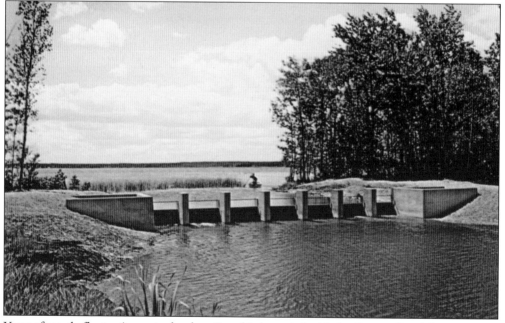

Years of greatly fluctuating water levels at Grand Lake ended with the County Road Commission's construction of a dam at the north end of the lake. On the other side of the dam, the Grand Lake outlet runs through Thompson's Harbor State Park on its way to Lake Huron. A popular fishing spot, it is next to the Fletcher–Gilchrest Park.

*Five*

# PRESQUE ISLE HARBOR

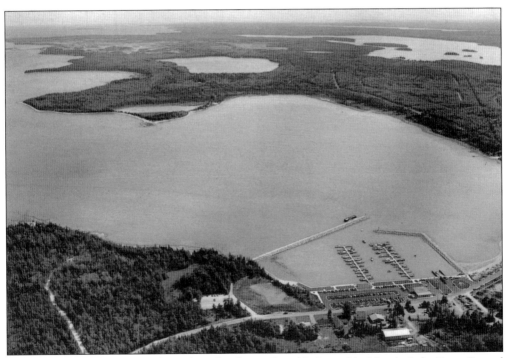

This aerial view of Presque Isle Harbor also shows Grand Lake and its islands, Lake Esau, Crystal Lake, North and South Albany Points, and Albany Bay. The Stoneport quarry is seen in the upper-left corner, and Middle Island is barely visible in the distance. Presque Isle State Harbor is pictured here with only two piers, but a third pier was added later.

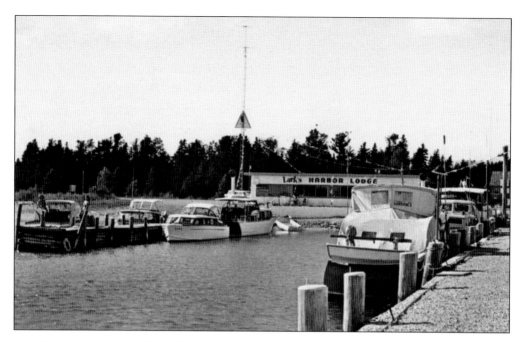

Louis Stubl purchased the former Harbor View Hotel property from Mel Karol, a local businessman. Karol lived on the west side of Grand Lake, and a road there bears his name. Stubl built new docks—one of which was 500 feet long for large craft—and added a dairy bar and general store for boaters. It is said that "Larks" stood for his sons' names: Louis, Andy, Roger, and Keith. Hydroplane races in the harbor were a highlight during some summers. Some of those hydroplanes, hand-built by eager Grand Lake teenagers, still rest on racks in boathouses around the lake unused and dusty.

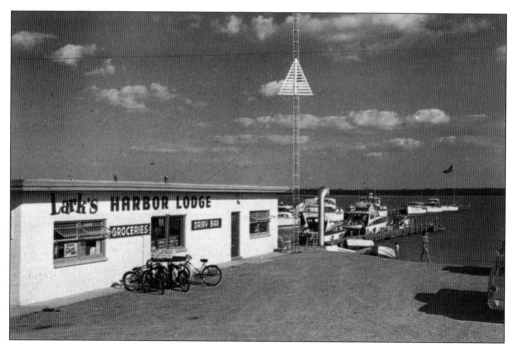

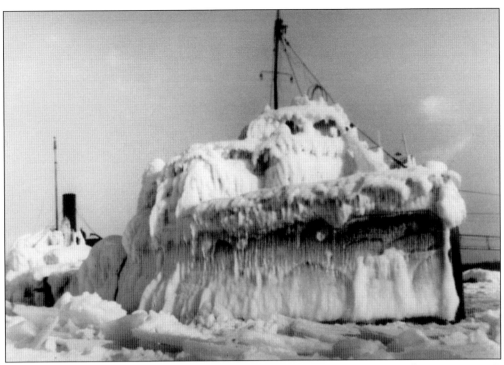

The photograph above, dated March 2, 1948, is of the Canadian freighter *William C. Warren*. It was carrying 88,000 bushels of wheat from Fort Williams, Ontario, to Toronto when it went aground during a Lake Huron gale. In an attempt to free the ship, some 20,000 to 30,000 bushels of wheat were thrown overboard. The wheat began to ferment, and thousands of ducks were seen feeding on the fermented grain. The drunk ducks were unable to fly, and nearby residents were able to easily pick them up—a marinated dinner ready for the taking. By the middle of April, the ship was dislodged and taken to Presque Isle Harbor for temporary repairs before it could make the trip to Collingwood, Ontario, for repairs. The image below shows part of North Bay. Black Point, where the *Warren* went aground, is not visible. The location is three miles west of the new lighthouse. (Above, photograph by Robert Larsen, courtesy of Robert Larsen.)

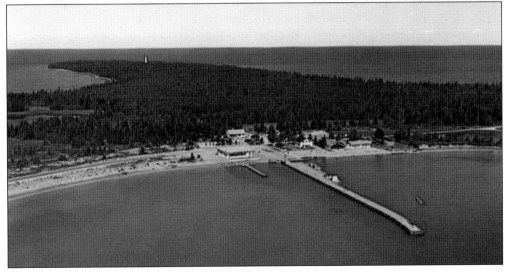

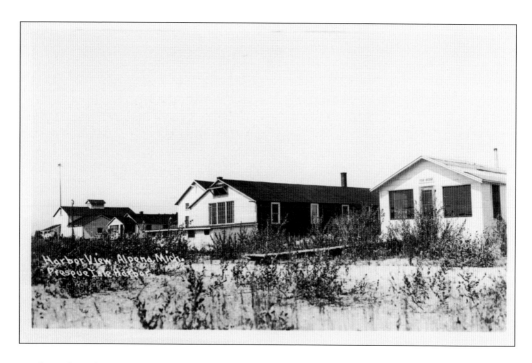

Fred Peipkorn built a store and a compound of cottages at Presque Isle Harbor in the early 1900s, which he called Harbor View Hotel. The structures were built on both sides of East Grand Lake Road. The freestanding fireplace seen below was attached to a structure that likely burned down during the 1908 Metz fire. As the final survivor of the three drinking buddies buried in Presque Isle Township Cemetery, Piepkorn had the honor of saluting his friends for over two decades before joining them in 1965. Future owners of this property included Mel Karol, Louis Stubl, and currently the State of Michigan.

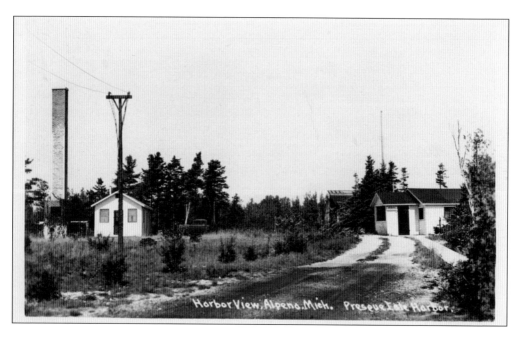

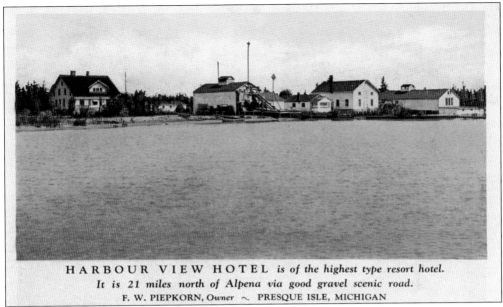

**HARBOUR VIEW HOTEL** *is of the highest type resort hotel.*
*It is 21 miles north of Alpena via good gravel scenic road.*
F. W. PIEPKORN, *Owner* ~ PRESQUE ISLE, MICHIGAN

This view of Piepkorn's compound includes a view of his home, rental and commercial properties, and a wharf, the latter of which was referred to as a "quay" by a budding journalist attending Kamp Kairphree in Bell in 1926. The young women from camp "who have asked that their names be withheld, mention having encountered a party in charge of the younger married set out strolling in the same direction. The two groups met at Piepkorn's quay where dancing was indulged in."

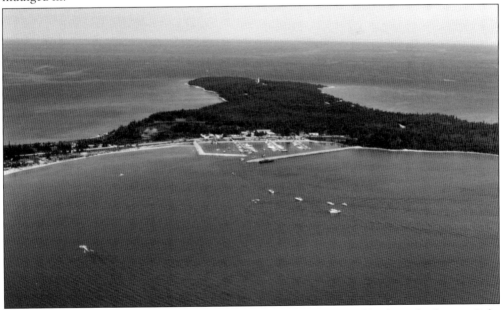

The portage to the left of the marina at Presque Isle Harbor is probably the only place on Lake Huron where one can stand in the same place and see both a sunrise and sunset over the water. The project manager for the Michigan Department of Natural Resources' Waterways Division project to build the new marina was local hero Les Nichols. The marina features The Portage Restaurant and a new, modern parking area and launch site.

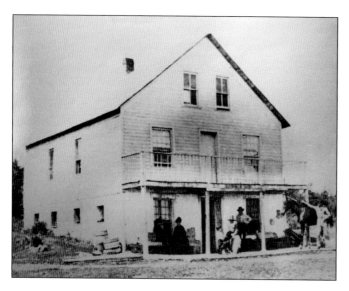

Frederick Burnham built two large docks and a home at Presque Isle Harbor, shown in this image. He owned 20 teams of horses for his lumber business. He and his wife sold eight and a half acres to the federal government in 1869 for $100. This sale allowed the government to build the two range lights to guide boats into the harbor at the time that the old 1840 lighthouse was decommissioned. (Courtesy of the Clarke Historical Library, Central Michigan University.)

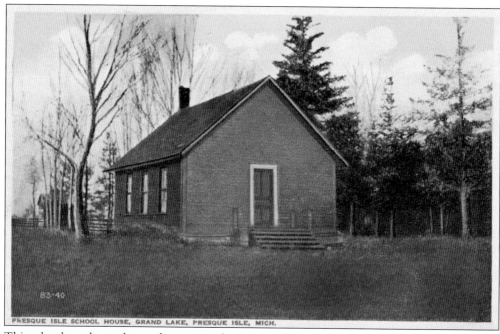

PRESQUE ISLE SCHOOL HOUSE, GRAND LAKE, PRESQUE ISLE, MICH.

This school was located near the present-day intersection of County Road 638 and East Grand Lake Road. The school was known for its floor, which was suitable for dancing and was used for community celebrations such as those on the Fourth of July. It likely burned down during the 1908 Metz fire, as the authors have been unable to locate anyone who can remember seeing the school during their lifetime. (Courtesy of RL.)

# *Six*

# LIGHTHOUSES

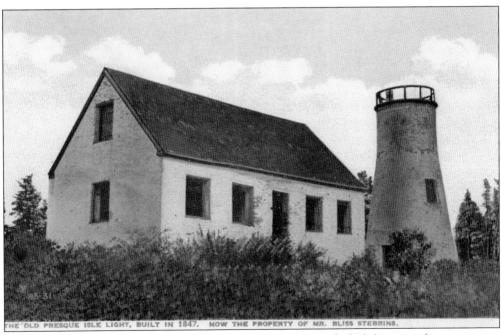

THE OLD PRESQUE ISLE LIGHT, BUILT IN 1847. NOW THE PROPERTY OF MR. BLISS STEBBINS.

In 1838, Congress appropriated $5,000 for the construction of a lighthouse at the entrance to Presque Isle Harbor. Jeremiah Moors, of Detroit, won the contract with a bid of $4,000, on August 24, 1839. Jeremiah contracted vessels, acquired building materials, and was on his way to Presque Isle when a gale on Lake Huron caused the captains of the vessels to throw Moors's property overboard or risk sinking. The date noted on this postcard is incorrect.

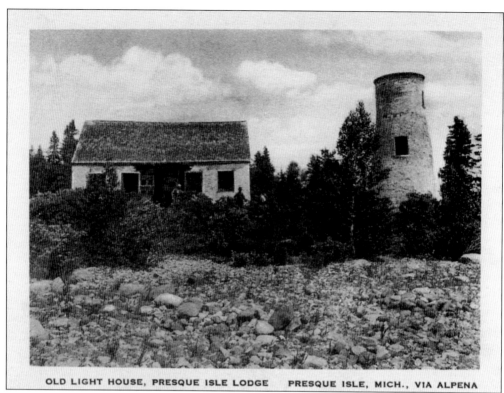

OLD LIGHT HOUSE, PRESQUE ISLE LODGE    PRESQUE ISLE, MICH., VIA ALPENA

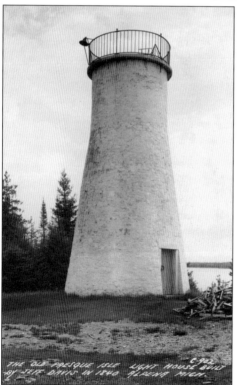

In 1840, Jeremiah Moors continued to have difficulty with the lighthouse project. Construction was finally completed, and on August 27, 1840, the light was lit. Interim keeper Lemuel Crawford was placed in charge of the light until the arrival of Henry Woolsey, the permanent keeper. Crawford received $3.50 for his tenure, which ended on September 30, 1840. (Courtesy of Walter Dawson.)

Most of what is known about the old lighthouse has been passed along in letters and documents. There were no day-to-day diary entries that recorded events as future logbook procedures would require. The practice of lighthouse keepers maintaining logbooks did not start until 1872. It is known, however, that after Lemuel Crawford tended the light, there were five other keepers: Henry Woolsey, George Murray, Stephen Thornton, Louis Metivier, and Patrick Garrity. (Courtesy of Presque Isle Township.)

The old lighthouse was initially fitted with an old-fashioned Lewis lamp that combined an Argand lamp with a parabolic reflector. In 1857, a modern, fourth-order Fresnel lens was installed. One of the original lamps from this lens is on display in a Presque Isle Township Museum Society facility. (Courtesy Archives of Michigan.)

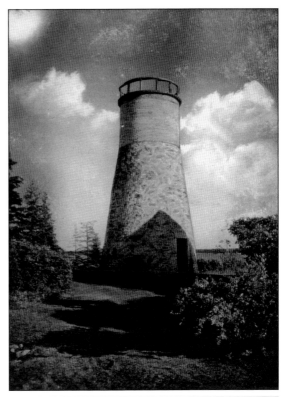

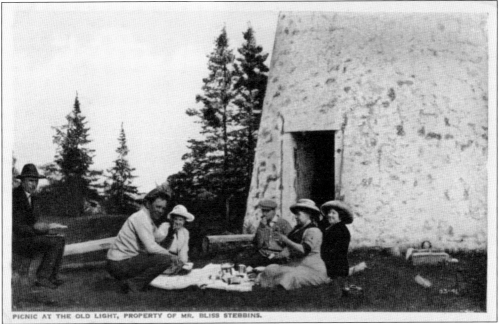

PICNIC AT THE OLD LIGHT, PROPERTY OF MR. BLISS STEBBINS.

The old lighthouse had several owners after being decommissioned. It was eventually purchased by Bliss Stebbins and used as a picnic area for his Grand Lake Hotel guests. Pictured in this 1916 postcard are, from left to right, George Kauffman; Mr. and Mrs. Rodemich, of Toledo; Mr. Wales, of Detroit; Mrs. Bliss Stebbins; and Mrs. Wales.

Even when the Garrity family left the lighthouse in 1870, the keeper's cottage was in disrepair. There are stories of other people living there for a time, but eventually the property was deeded to Francis B. Stebbins. Stebbins thought it was necessary to tear down the cottage and rebuild it on the existing foundation. This was done in the 1930s. (Courtesy of Presque Isle Township.)

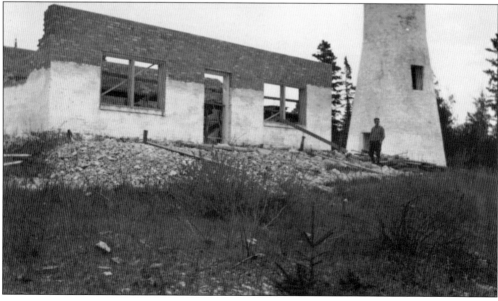

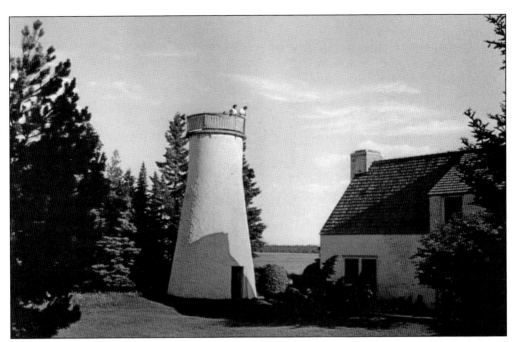

Francis rebuilt the structure to serve as a cottage for his guests, but the tower also needed attention. Litter, which had blown in through broken windows and the door, was removed, and a new cement top was built and installed, along with a railing, a new door, and new windows.

Fred May, a Grand Lake resident, was commissioned to design and build a replacement lantern room in 1961. A crane was brought in to position it. James Stebbins, son of Francis, purchased a fourth-order Fresnel lens at a Coast Guard auction, and it was placed in the center of the lantern room, where it remains today. (Courtesy of Presque Isle Township.)

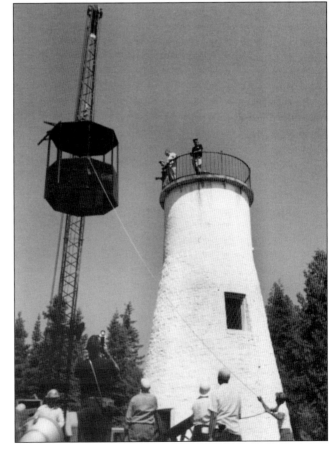

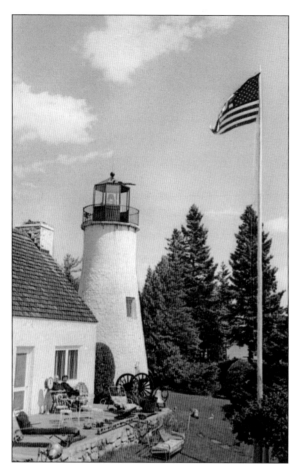

These more current postcards of the old lighthouse illustrate how the appearance of the lighthouse grounds and deck have changed over time. The Fresnel lens seen on the porch in these two images was donated to a lighthouse group needing a lens. It was a part of the owner's collection but was not used at the old lighthouse. The bell from Lansing City Hall is visible below. It was procured when the building was being demolished.

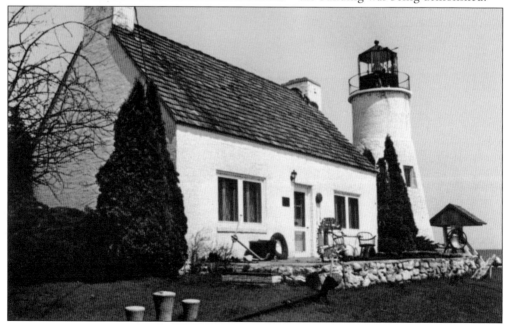

This image shows the road to the old lighthouse prior to 2009. At that time, dramatic changes were undertaken by Presque Isle Township to widen the road.

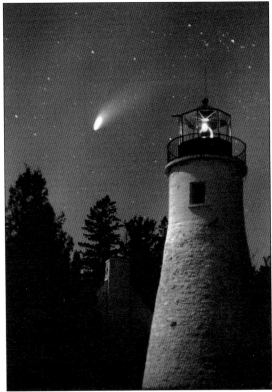

This is one of the most popular images of the old lighthouse. The scene was described in the Kamp Kairphree journal: "Matrons of Presque Isle colony were appropriately upset when their debutante daughters bandied words with two young men. . . . The latter advised the girls not to go on to the lighthouse because it was haunted by ghosts at night; whereupon one of the debs replied, 'Oh, that's all right. I've spent a whole night there.' " (Courtesy of William D. Lewis.)

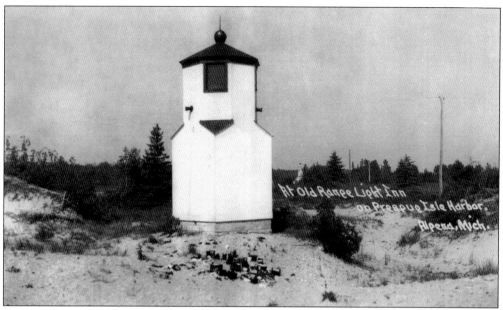

The first keeper at the range light was Isaac Coddington, who was reprimanded in 1873 for not writing in the logbooks as directed. Capt. William Sims took over the position in June 1875 and stayed until 1887. He buried his wife, Adeline, near the shore of Presque Isle Harbor in 1881. The postcard above shows the original front range light. The photograph below shows the rear range light, which also housed the keeper. While working as a counselor at the girls' camp in Bell, Ruth Vermilya became aware of these range lights. After she married Eugene Cleland, they purchased the rear light and along with her mother turned it into an inn that functioned like a tearoom by offering light fare to visitors. (Below, courtesy Archives of Michigan.)

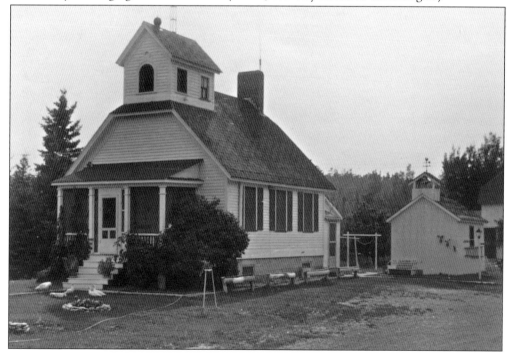

Anna Garrity, one of the few female lighthouse keepers, maintained the range light after her father's death in 1903. She spent 23 years tending the light. She also had a male assistant, Vince Newagon, for a few years, which was unusual in those days. The photograph at right shows the front range light, which replaced the original front light. As ships entered the harbor, captains had to position their ship so that the rear light was directly above the front light in order to guide the ship safely through the channel to the dock. (At right, courtesy Archives of Michigan.)

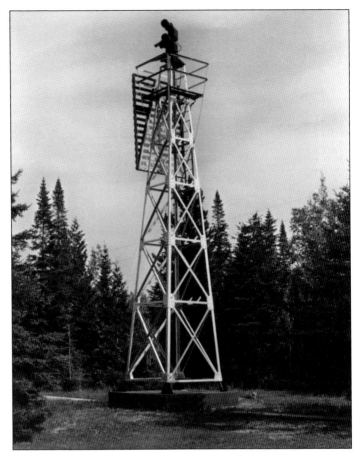

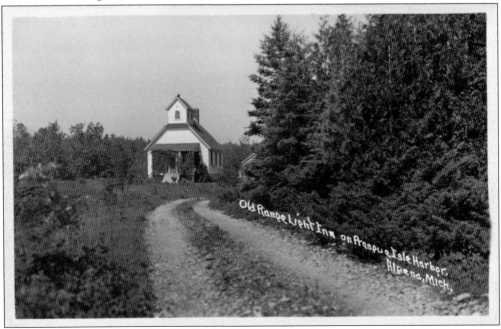

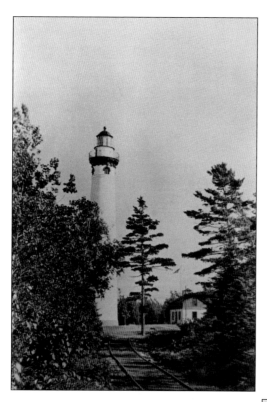

This postcard of the "new" lighthouse shows the tramway that was installed to make the off-loading of supplies from ships more efficient. At a later date, the tramway was extended from the tower to the boathouse on North Bay. A building is visible to the right of the tower, which was used as an office by lighthouse keeper Ralph Gates.

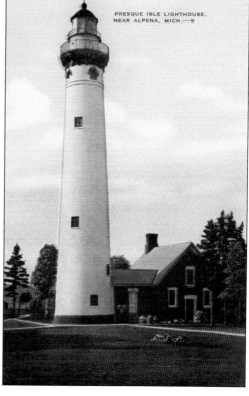

In 1870, O.M. Poe was the engineer in charge of building lighthouses for the government. To expedite the building of the new Presque Isle Lighthouse, he used plans that had been previously used for the Grand Point AuSable Lighthouse, located on Lake Michigan between Point Betsie and Muskegon, and the Skillagalee Lighthouse, located on the Ile Aux Galets south of the Straits of Mackinac.

Supplies for the light were delivered by August 1, 1870, by the tender *Henry Warrington*. The report of the Lighthouse Board states that the station "was unexpectedly completed in 1870 before winter set in." According to logbooks, this was in November. It is easy to imagine the excitement of the keeper's family, anxious to move into the new, large, modern quarters before winter. The light, however, was not lit for the first time until the beginning of the 1871 shipping season.

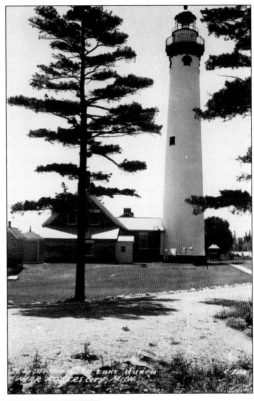

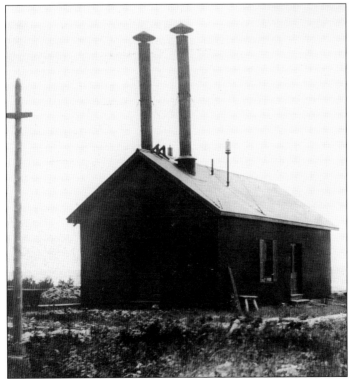

Congress appropriated $5,500 to establish the fog signal in 1889. This building was constructed in 1890, with two iron smokestacks. In 1904, they were replaced with a 45-foot-tall brick chimney. The 10-inch steam whistle produced a five-second blast, followed by a 25-second silent interval. This repetitive wistful moan is fondly remembered by those who considered it a welcome addition to dull, dreary days. It was demolished in 1968 and is now the site of a picnic pavilion.

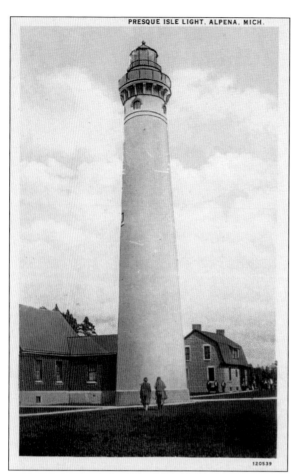

PRESQUE ISLE LIGHT, ALPENA, MICH.

120539

Ruth Doyal served the citizens of Presque Isle Township as treasurer and Presque Isle County as a commissioner. In the 1970s, she obtained a lease for the 1870 lighthouse property and the front range light property. She wrote numerous letters to different government agencies requesting the properties for the township as well as having Alpena Community College, Rogers Union School District Number 1, and Presque Isle County defer any interest in the properties. Eventually, through the efforts of Les Nichols, ownership of the 99 acres around the lighthouse, and all buildings thereon, was transferred to the township.

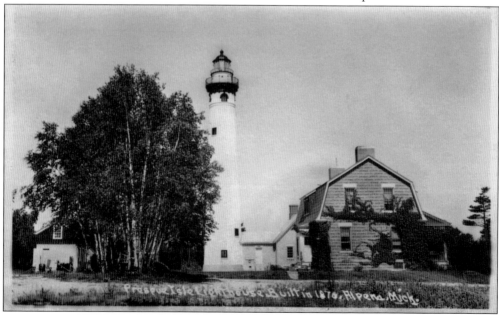

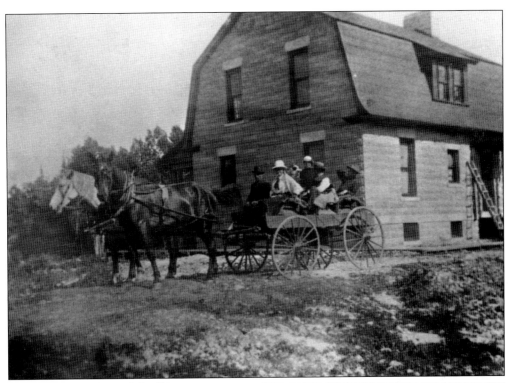

The need for additional dwelling space was recognized upon the completion of the fog signal in 1890. The newly constructed keepers' quarters certainly must have seemed elegant in comparison to the 1870 dwelling attached to the lighthouse. Keeper Thomas Garrity, a bachelor, moved into this new home with his sister Kathryn, who kept house. She also managed the weather flags, which were displayed on a tower at the shoreline and visible to those on passing ships. During this time, the range light keeper, Patrick Garrity, and his wife, Mary, moved in with Thomas and Kathryn at the end of the shipping season because they did not have to maintain the range lights in the winter and because it was much easier and more economical to heat one home rather than two.

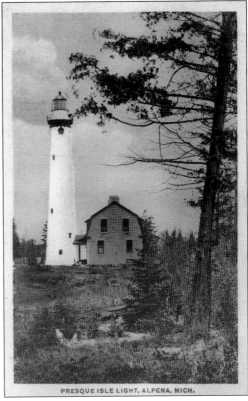

PRESQUE ISLE LIGHT, ALPENA, MICH.

103

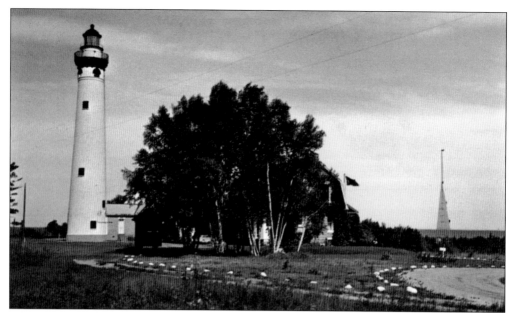

This image of the new lighthouse includes the outhouse for the newer keepers' dwelling, built in 1905. There were two separate outhouses at the 1870 dwelling, one at the side and one behind, because it had been turned into a duplex. Views of the tower at right are unusual for postcard images. This signal tower was used by Kathryn Garrity to hoist flags and alert those on passing ships of weather conditions.

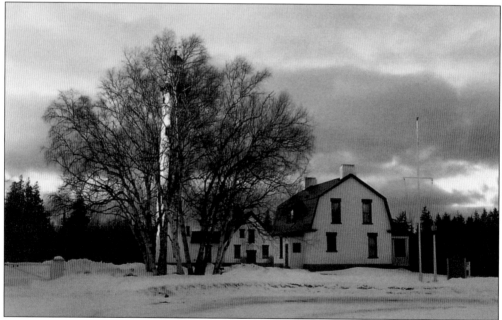

The appearance of the new lighthouse changes dramatically from summer to winter. People visit New Lighthouse Park year-round. In the winter months, they can enjoy skiing, snowshoeing, and watching the waves of Lake Huron crash on the shore creating huge ice sculptures. A sign designating the site as a state historic site is visible at right. The marker was dedicated on July 6, 1991. (Photograph by Dan Rivard, courtesy of Carol and Dan Rivard.)

At some point, Coast Guard caretakers used the wrong paint on the lighthouse, causing the surface of the bricks to spall, or flake off. The paint did not allow moisture to escape, and when the moisture froze and expanded, the spalling effect took place. Between 1988 and 1989, the outer layer of bricks had to be removed and replaced with glazed brick.

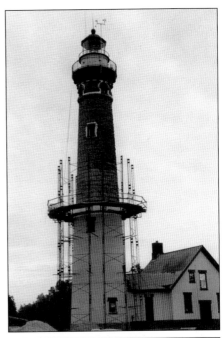

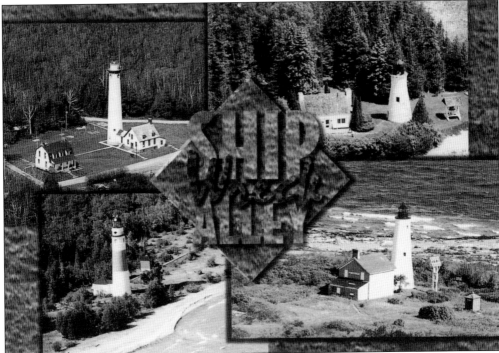

The lighthouses shown on this postcard are, clockwise from the upper left, the new Presque Isle Lighthouse, the old Presque Isle Lighthouse, the Thunder Bay Island Lighthouse, and the Middle Island Lighthouse. The smaller window in the upper left of the new lighthouse keepers' quarters was installed in the 1930s to accommodate Vincent Newagon, second assistant to the head keeper. His arrival required the US Lighthouse Service to modify an attic space for his lodging. (Courtesy of Perrin Souvenir Distributors.)

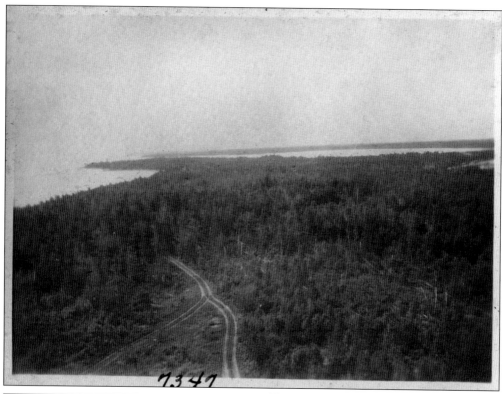

7.3 47

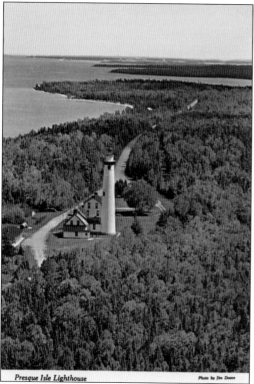

Here, it is possible to note the change in road access to the new lighthouse. The photograph above was taken in 1922 from atop the lighthouse and shows the road's position at that time. After Elmer Byrnes, keeper from 1935 to 1954, became snowed in, he requested that the road be straightened and upgraded. (Above, photograph by George R. Swain, courtesy of Joyce Swain Benson.)

Presque Isle Lighthouse                    Photo by Jim Doane

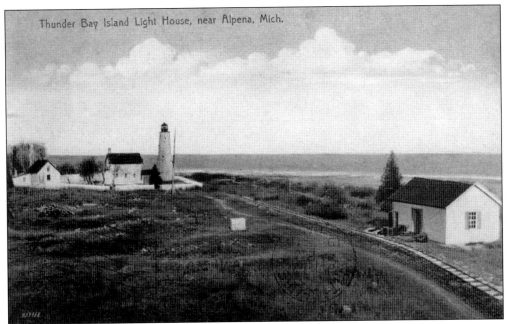

Thunder Bay Island Light House, near Alpena, Mich.

In 1831, Congress appropriated $5,000 for a lighthouse on Thunder Bay Island. Before completion, a storm surge washed out mortar to a height of 10 to 15 feet and the tower fell. The building was finally completed in 1832, and Jesse Muncey was appointed first keeper. In 1857, the height of the tower was increased by 10 feet, and a fourth-order Fresnel lens was installed.

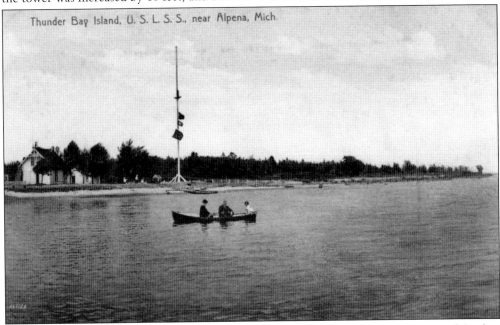

Thunder Bay Island, U. S. L. S. S., near Alpena, Mich.

The US Life Saving Service opened a station on Thunder Bay Island in 1876—one of the first on Lake Huron. The captain in charge was removed because the schooner *Charles Hinkley* grounded in the area and did not receive aid. John D. Persons was appointed as his replacement. He served at this post from 1877 to 1915. Persons claimed that his station saved over 1,000 lives. (Courtesy of RL.)

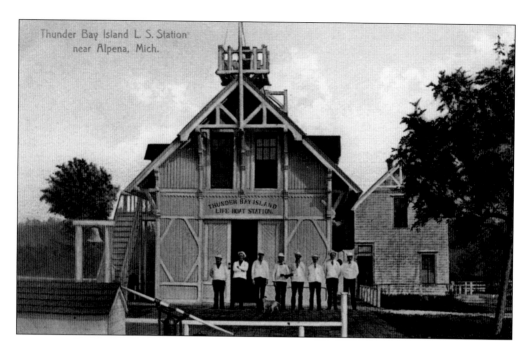

The US Life Saving Service was created in 1871. The first stations in the Great Lakes were built in 1875. They fell into three categories: lifesaving, lifeboat, and houses of refuge. In general, the stations in the Great Lakes were lifeboat stations, but there were some lifesaving stations in remote locations. The Thunder Bay Island Life Boat Station was built in 1876, and the Middle Island Lifesaving Station was built in 1881. The Coast Guard took over for the USLSS in 1915. The most convenient times to visit both islands is during the Great Lakes Lighthouse Festivals in October, when charter boat trips are scheduled. (Both courtesy of RL.)

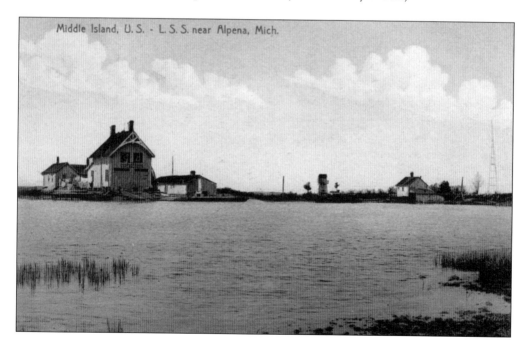

# *Seven*

# COMMUNITY OF BELL

This is one of the two rarest postcards that appear in this publication. It shows a scene on Bell River in 1908. The river separated the "island" from the mainland before the quarry operation filled in its northern end and turned the island into a peninsula. Many residents still refer to False Presque Isle as "the island" for this reason.

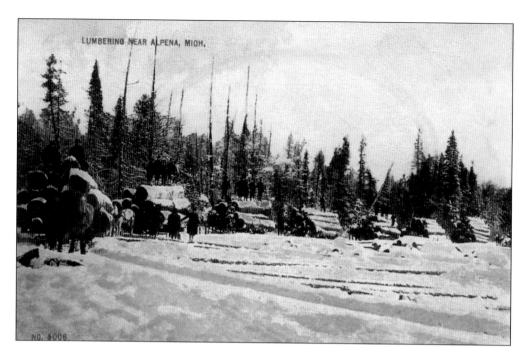

Bell was an active lumbering center. The images seen in these postcards might well have been taken at or around Bell. There was a sawmill in Bell, with a loading dock extending north into the middle of Bell Bay. Trams were used to carry logs, lathe lumber, and bark. Trams from a sawmill at Grand Lake traveled along wooden tracks, with each horse pulling two cars down the track to the dock in Bell. There, the contents would be loaded onto ships. Additional tracks led to Bell, including one along Rayburn Road. (Both courtesy of Robert Currier.)

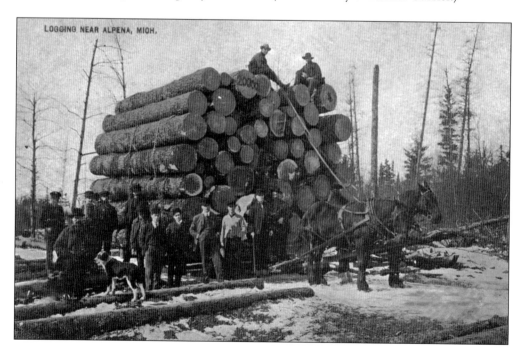

Henry Rabiteau was a lumberjack and fisherman who lived on False Presque Isle. He was one of the men on an ill-fated sailboat trip in 1898 when an unexpected storm flipped their boat over. They were expected at the Fourth of July celebration held in the Presque Isle schoolhouse, a half mile south of the range lights. Friends did not learn until the next day that Henry and another man had clung to the boat to survive while their companions perished. (Courtesy of the Clarke Historical Library, Central Michigan University.)

John Charbonneau was born in Quebec. He moved to Bell from St. Ignace with his wife. Indians had been living on the 120 acres that he homesteaded, and he appropriated the cedar bark longhouse they left behind. As a young man, he worked for the government delivering mail from Detroit to Sault Ste. Marie. He died at age 103 and is buried in Bell Cemetery. (Courtesy of the Clarke Historical Library, Central Michigan University.)

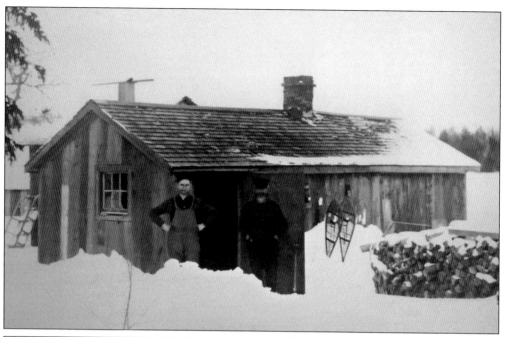

This is one of the few photographs showing homes in Bell when it still existed. Pictured here are Byron Olds (left) and Henry Rabiteau on February 12, 1910. It is hard to imagine living in this structure during northern Michigan's cold winters. (Courtesy of the Clarke Historical Library, Central Michigan University.)

William French's home in Bell was built from bricks made at the Presque Isle Brick and Lumber Company. The company's kiln was located in an area just north of the current entrance to the Stoneport quarry. Clay used in the bricks was dug from deposits nearby. Today, those pits are ponds and can be seen to either side of East Grand Lake Road. (Courtesy of APL.)

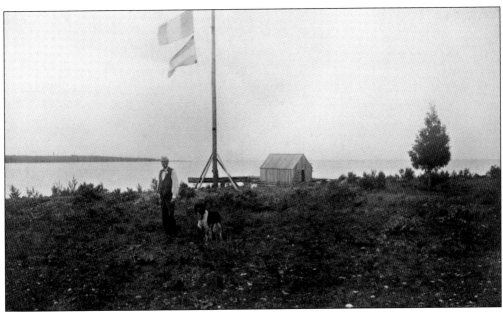

Bell's Bolton Point was named after Henry Bolton, pictured here. He was born in Ireland in 1843 and arrived in Alpena in 1864. The summer home he built at Bell Point was a stately two-story, white-frame home. He entertained many there, including the Duke and Duchess of Manchester. Bolton called this area "The Pines," and today it is known as Bell Pines. (Courtesy of APL.)

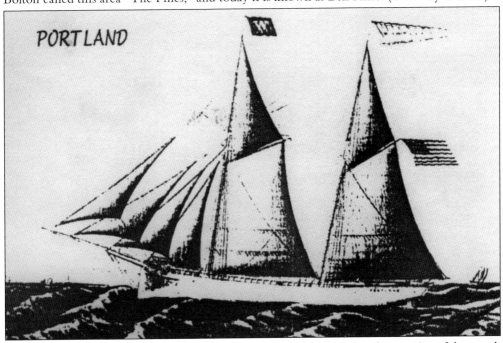

The schooner *Portland* sank at Bell in 1877. The area is so shallow that the remains of the wreck can be seen in satellite photographs. It lies off Bolton Point and is a popular kayak and skin-diving destination for people who want to explore a shipwreck without scuba equipment. The wreck is 460 feet from the tree line on shore. Parts of the *Portland* also lie in the small pond inland from the beach. (Courtesy of APL.)

The "good auto road" mentioned in the advertisement below could not have referred to the last few miles to Bell, but this location had other features that prompted George R. Swain and his wife, Edith, to establish a camp for girls there. George Swain was the University of Michigan's first official photographer. Swain's photograph logs show that about 500 of his images were taken in and around Bell between 1922 and 1927. The authors were able to locate one of his relatives, who graciously provided a 92-year-old family picture album that contains many photographs, including the one at left, taken in 1922 and described by Swain as "road above camp . . . 3 birches at left." The numbers that appear on some photographs in this book, 7209 in this case, refer to the sequential numbering of his 13,344 photographs. (At left, photograph by George R. Swain, courtesy of Joyce Swain Benson; below, courtesy of the Alumni Association of the University of Michigan.)

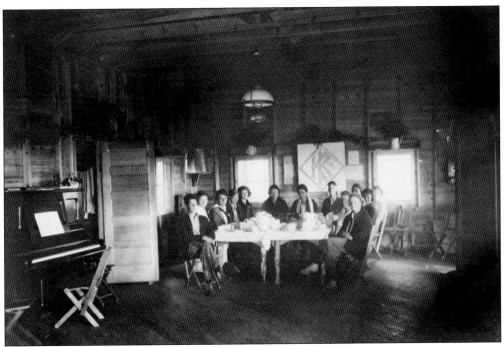

Until recently, it was assumed that the only historical structure from Kamp Kairphree in the Besser Natural Area at Bell is what remains of the lodge's fireplace. It is conjecture at this point, until someone locates one of the missing Swain images. His photograph log clearly indicates that no. 8436 shows the lodge's fireplace. These images of the interior and the exterior of the lodge show that in 1922 it did not have a fireplace. (Both photographs by George R. Swain, courtesy of Joyce Swain Benson.)

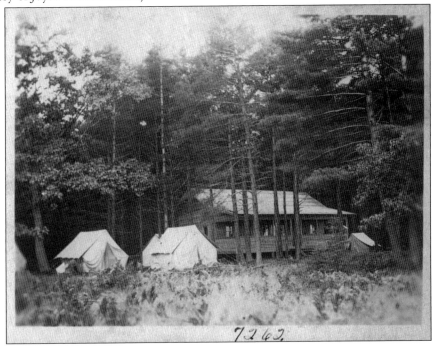

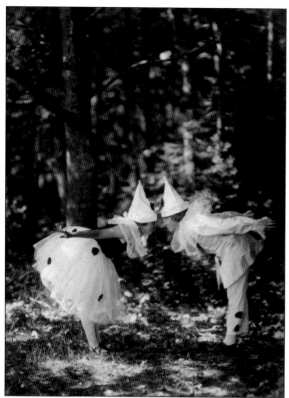

Kamp Kairphree girls were involved in numerous activities. After arriving by train or automobile and leaving civilization behind, they adjusted to a primitive life without modern comforts. Overnight hikes to Presque Isle Harbor, visiting lighthouses, the midnight exploration of a "haunted" house, and trips to locations like the Calcite plant in Rogers City were just a few of the activities that they enjoyed. In 1928, after six years at Bell, Kamp Kairphree was moved to Lake Charlevoix in northwest Michigan. (Both photographs by George R. Swain, courtesy of Joyce Swain Benson.)

# *Eight*

# NEARBY ATTRACTIONS

This postcard shows the port of Rockport, with its dock and power plant. Rockport, a designated state recreation area, became Michigan's 100th state park in 2012.

This image shows the sophisticated facility used to load ships with limestone from the Rockport quarry. No evidence of this structure remains, and portions of the dock on which it stood are slowly eroding into the lake.

This view of the power plant at Rockport looks toward the southwest. The road to Bell is seen in the upper-left corner. Even in the late 1960s, the power plant building still stood, containing the remnants of work orders, billings, and receipts. (Courtesy of the Clarke Historical Library, Central Michigan University.)

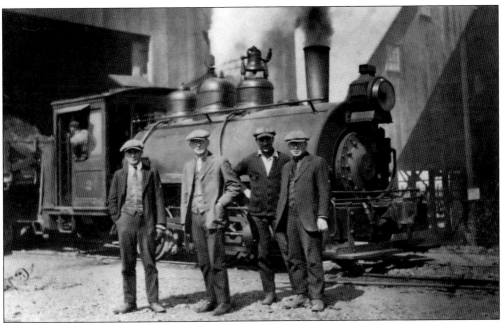

These photographs show early scenes of the operations at the Rockport quarry. Construction began on January 15, 1913, with the site designed as a new plant to quarry and ship stone. Great Lakes Lime and Stone started quarrying on July 6, 1913, and on June 20, 1914, the first stone left the port. Kelley Island Lime and Transport, of Cleveland, Ohio, purchased the business in 1921. The photograph above of four men standing in front of locomotive No. 2 on the Crusher Dump Track was taken on September 2, 1922. The photograph below of the crusher, screening building, elevator buildings, and the conveyor bridge was taken in November 1933. (Both courtesy of APL.)

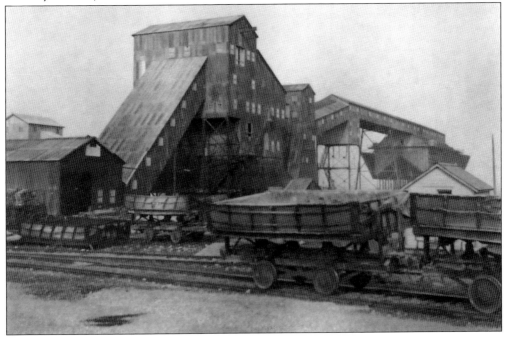

The decreasing quality of the limestone deposit led to the establishment of a new quarry at Stoneport, seven miles to the north. For the first few years of Stoneport's operation, the stone was transported by rail to Rockport to make use of the harbor that had been established there. Construction of the Mackinac Bridge provided an opportune time to reuse the Rockport site for industrial purposes in 1954. These photographs show the assembly of the caissons that were used to anchor the two mammoth towers of the bridge. (Both photographs courtesy of the Mackinac Bridge Authority.)

Sections of the caissons were fabricated in a US Steel plant in Gary, Indiana, and were shipped to Rockport. There, they were assembled into double-walled rings that were 44 feet high and 116 feet in diameter. A channel was dug between the site and Lake Huron, and the caissons where floated until they could be towed to The Straits. There, the caissons were filled with rocks to make them sink into position—200 feet below the surface. (Both photographs courtesy of the Mackinac Bridge Authority.)

For many of the workers at Rockport, lodging was available on-site. Photographic documentation prepared for the company's insurance carrier shows a superintendent's dwelling, bunkhouses, dwellings, a "Polish Workmen's Bunk House," and a boardinghouse. The postcard above shows the hotel at Rockport, and the photograph below shows "Dwelling Building No. 37." (Above, courtesy of the Presque Isle Township Museum Society; below, APL.)

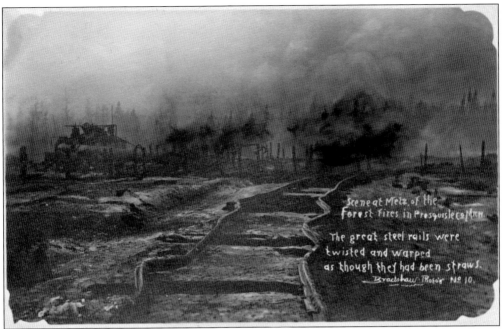

The Metz fire of 1908 had a huge impact on the entire area, as it extended across Presque Isle to the Lake Huron shore. The Presque Isle Lighthouse logbooks document the sighting of smoke and flames across North Bay and the fire's advance toward the harbor and peninsula. Due to the efforts of the lighthouse staff, residents, and people brought in from Alpena, government properties were spared destruction. (Courtesy of RL.)

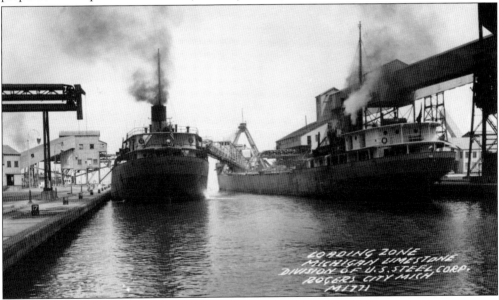

The Calcite quarry in Rogers City is the world's largest limestone quarry. A Kamp Kairphree camper's report of a 1926 field trip states, "Everyone piled out and made for the quarry . . . where they could breathe 'dustily' and ramble about at obtuse angles and look at tipping landscapes, which matched their moods, exactly. . . . Mother Swain [the camp's director] took two of us down to see a freighter load, which was very interesting."

*Sunken Lake near Alpena*

*March 5/07*

*I didn't go fishing today nor did I need a bathing suit JWSG*

Sunken Lake used to extend westward toward Leer Road. This area is now home to the Mystery Valley Karst Preserve and Nature Sanctuary. Logs could not float down the North Branch of the Thunder Bay River until a dam was built, which today provides access to a campground created when Sunken Lake was given to Alpena County as a county park—even though it is located in Presque Isle County. (RL.)

Department of Natural Resources literature describes Ocqueoc Falls as the highest waterfall in the Lower Peninsula, which leads some to erroneously think it is the only such waterfall. In 2011 and 2012, improvements to the Ocqueoc Falls Bicentennial Pathway resulted in Ocqueoc Falls being a finalist for the 2013 da Vinci Award. It captured the top prize in the competition's environmental category. The pathway has been recognized as having the most universally accessible waterfall in the country. (Courtesy of the Upper Peninsula Card Company.)

Swan Falls is a beautiful series of waterfalls a few hundred feet off US 23 northwest of Grand Lake. A visitor's postcard message could have been that expressed in M.R. Potter's unpublished memoir, *Years at Grand Lake*: "From Trout Creek [US 23] branches off to the northwest and crosses the Swan River. A few hundred feet north are the Falls Kate and I visited two years ago and found so little known. When 23 is completed this will probably make them one of the attractions." Despite the optimistic prediction, Swan Falls has not become a tourist attraction because it is located on private property. The exact location of the falls is generally unknown, so they are rarely visited. The authors gained permission from the owner to photograph the falls during the winter. The image below suggests that the falls are beautiful year-round.

The German steamer *Nordmeer* became stranded on Thunder Bay Shoal in November 1966. It was abandoned nine days later and rests on the bottom of the lake. The many shipwrecks in and around Thunder Bay have earned it the title "Shipwreck Alley." The theft of underwater artifacts has led to preservation efforts, and a proposal to designate Thunder Bay as a national marine sanctuary was formulated by one of the authors and John Schwartz, the local Sea Grant agent at the time.

The proposal was submitted on May 13, 1982, in response to a Federal Register announcement. The 24 potential sanctuary sites were reduced to 10 and later to 5. Finally, the Thunder Bay National Marine Sanctuary and Underwater Preserve, off Alpena, was dedicated on October 7, 2000. On September 5, 2014, the sanctuary was increased from its original 448 square miles to 4,300 square miles, including waters off Presque Isle County.

Three state parks provide nearby attractions, and activities in these parks are guided by a single general management plan. Portions of Rockport are within Presque Isle Township, and Thompson's Harbor is contiguous to the township. Negwegon is just south of Alpena. Together, these state parks offer over 20 square miles of wilderness land and 22 linear miles of undeveloped Lake Huron shoreline. Public access is assured, though camping is allowed only at primitive, isolated sites within Negwegon. With natural and historical protection guaranteed, visitors can view the rock formations of undetermined origin within Negwegon (above) and the shipwreck remains on the shoreline of Thompson's Harbor (below). The peace, quiet, and solitude found in these three public parks are symbolic of the values that bring people to the Presque Isle area.

# DISCOVER THOUSANDS OF LOCAL HISTORY BOOKS FEATURING MILLIONS OF VINTAGE IMAGES

Arcadia Publishing, the leading local history publisher in the United States, is committed to making history accessible and meaningful through publishing books that celebrate and preserve the heritage of America's people and places.

Find more books like this at
**www.arcadiapublishing.com**

Search for your hometown history, your old stomping grounds, and even your favorite sports team.